May i
take your

Indexed
10/15/04

Box 1

JIM

CHRONICLE BOOKS
SAN FRANCISCO

To My Dining
Companions
Roleen and Zoë

Copyright ©1998 by
Jim Heimann. All rights
reserved. No part of
this book may be
reproduced in any form
without written
permission from the
publisher.

Library of Congress
Cataloging-in-Publication
Data available.

ISBN 0-8118-1783-0

Printed in Hong Kong.

Book and Cover Design
by Jim Heimann.
Production by
Mechanical Men, Inc.

Distributed in Canada by
Raincoast Books
8680 Cambie Street
Vancouver, B.C. V6P 6M9

Chronicle Books
85 Second Street
San Francisco, CA, 94105

10 9 8 7 6 5 4 3 2 1

Web Site:
www. chronbooks.com

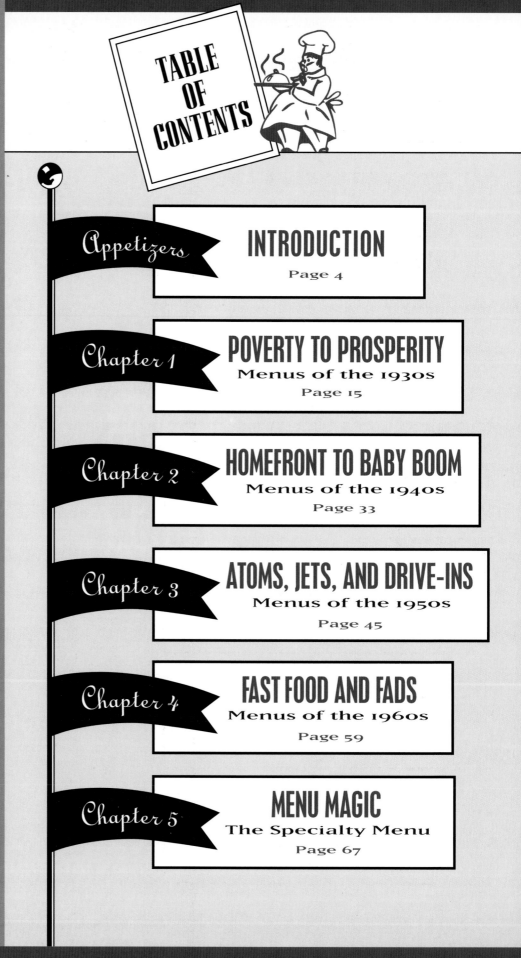

TABLE OF CONTENTS

MAY I TAKE YOUR ORDER?

Specials

May We Suggest?

A tip of the toque to John Baeder
Brad Benedict, Desoto Brown,
Ralph Bowman, Dan De Palma,
Gary Fredericks, Alan Hess,
Patrick Jenkins, Dave Lathom,
John Margolies, Jeff Moureau,
Paul Mussa, Chris Nichols,
Tom Quintana, Fred Quintana,
Don Sanders, Kathy Staico-Schorr,
Peter Shire, Tommy Steele,
Martha Spellman, Tom Zimmerman
and all the folks who provided me
with and loaned from their
collections some of the menus and
ephemera herein.

Also a nod of gratitude to
Blue Trimarchi and the staff at
Artworks for their competent
handling and photographing of
several thousand images
for this book.

At Chronicle my editor Lesley
Bruynesteyn, who walked me
through this project with
expertise and understanding,
Bill LeBlond, my editor at
Chronicle for almost twenty
years, and Pamela Geismar,
who continues to make the
design process a breeze.

To Lexy Scott, Craig Butler,
and the Workbook for their
continuous support and for
publishing the first article I
wrote on menu design in
Single Image.

To Genine Smith for her
production work on the
proposal.

A very special
thank-you to Tina Glaub
and Tracy Thomas of
Mechanical Men for their
continued expertise in
producing the digital
composition and
production.

Delicious Pies and Cakes
Baked Fresh Daily.

ur guests are invited to inspect, at all hours, our all-electric, stainless-steel, vermin-proof kitchen. All
dishes are sterilized in washing at 180 degrees.

Introduction

Gastronomic history tells us that in early restaurants the recitation of the bill of fare became an increasingly long-winded affair and written menus were instituted to guide diners in their eating choices. This written menu was commonly scrawled on a chalkboard or listed on a board conveniently visible to the customer. Developments in printing afforded a change in this presentation. As the number of food items increased and the logistics of a restaurant's floor plan inhibited a singular handwritten listing, printed menus were introduced.

Delmonico's restaurant in New York is often credited with introducing the first printed menu in the United States in 1834. That menu and others of the period were simple in design, offering straightforward information. Special occasions and commemorative events called for unique treatments in menu design and eventually gave rise to elaborate printed presentations. Menus from the first part of the twentieth century tended to follow this trend. Typically, they featured much attention to detail and to printing, and many were as elaborate and fussy as the era that spawned them: Gold leaf,

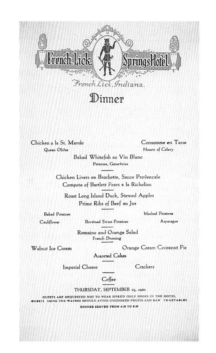

embossing, elaborate die-cuts, hand painting, and ribbons were used in profusion. The craftsmanship was superb, but limitations of the printing craft inhibited a full range of design executions. For the most part, motifs followed conventions and art movements of the time, with Victorian fluff spilling over into flowing Art Nouveau, which in its turn gave way to more functional designs inspired in part by the rise of poster art.

These specialized menus were usually reserved for that small segment of society with the money and status to dine outside the home. By the beginning of World War I, eating outside of the home increased as Americans moved to urban centers. Restaurant sales increased as workers ate their meals closer to the workplace. With the mass use of the automobile, eating in restaurants became commonplace, and the menu began to take on more prominence.

Advances in printing technology, advertising, and the commercial arts in the 1920s focused attention on the menu as a marketing asset. Restaurant management improved design and artwork. Anonymous artists in printing plants

A simple card menu from an Indiana resort hotel noted for its curative waters. French Lick Springs Hotel, September 23, 1920.

generally created the artwork for menu graphics. Well-known illustrators and designers shied away from menu cover design because of restrictive budgets. Thus the work of artists such as Maxfield Parrish, James Montgomery Flagg, J. C. Leyendecker, Norman Rockwell, and others rarely, if ever, appeared on the cover of a menu. Existing artwork might be employed for covers, as was the case in the menu of New York's Cafe des Artistes, which featured a portion of Howard Chandler Christy's mural extracted for cover art, or the Fred Harvey menus, which used Grant Wood prints for a series of their covers.

Posters dominated graphics from the turn of the century to the 1920s. They promoted products before the era of radio, television, and motion pictures, which soon diminished the posters' importance. But the principles behind poster imagery translated easily into menu cover art. Strong, bold graphics of the posters worked well with the cover panel a menu provided. In many ways, menu covers were small posters.

Inspired by the Jazz Age and the Paris Exposition of Decorative Arts in 1928, the Art Deco style was incorporated into menu covers by restaurants identifying with all that was modern and up-to-the-minute. Supplemented and eventually eclipsed by other decorative styles as the decade waned, it was a distinctive expression for many cafes of the period.

By the 1930s the menu was seen as a part of a restaurant's program to create a memorable meal. It could whet an appetite, tell a joke, explain a food item, create a mood, and above all,

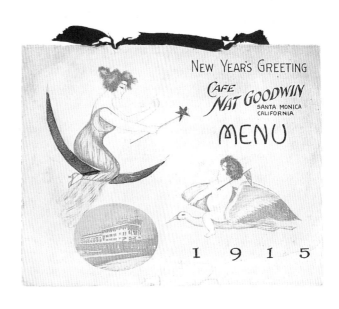

Top. A decorative New Year's menu from the New Grand Hotel, North Yakima, Washington, 1916. *Bottom.* Former vaudevillian Nat Goodwin celebrated the arrival of 1915 at his early Hollywood hangout with this specially commissioned menu.

sell some food. Competition among various chains as well as individual restaurants required that all of the components of a business be scrutinized and exploited. Restaurant trade publications encouraged the use of the menu as part of this business strategy, and the National Restaurant Association promoted effective menu graphics in its annual competition. Their guidelines for judging included 1) originality, 2) legibility, 3) ease of handling, and 4) sales effectiveness. *Restaurant Management Magazine* in its November 1936 issue further declared the menu's physical appearance to be "grossly under-estimated." The magazine went on to say, "A menu has two functions: 1) To sell food; and 2) to repeat, emphasize and accent the whole atmosphere you are trying to sell."

Acknowledging the menu as an integral part of a restaurant's makeup created a cottage industry for printers who were responsible for a large segment of menu production. Artwork created for the menu cover could be generated by the restaurant, by an in-house art department, by the printing company's art department, or by a collaboration of both

Piries Cafe, Fargo, North Dakota. September 8, 1913. A simple calligraphic engraving serves as a stock format for this mimeographed menu.

client and printer. Artists drew upon visual references familiar to them and compatible with a restaurant's clientele. Populist tastes usually dictated cover solutions—menu art tended to follow trends, not create them.

In addition to original designs, menus could also be bought in a generic form from business stationers and mail-order houses. These stock menus served as covers with food listings inserted as typewritten or mimeographed sheets. Food, beverage, cigarette, or other vendors often provided a restaurant with a stock menu incorporating their product on the front or back as advertising. This use of stock menus was a popular alternative for budget-conscious restaurants, although, here again, the artwork was more familiar than cutting edge.

With the end of Prohibition in 1933 alcohol was again available to thirsty Americans, and restaurateurs gladly incorporated its sale at their establishments. Liquor, cocktails, beer, and wine became an integral part of most restaurants, and separate menus were created for their promotion and sale. Table tents, wine lists, placemats, and napkins were used as aggressive printed sales tools to push these beverages. This area of advertising proved to be highly creative because of its singular focus. Printers encouraged the use of three-dimensional stand-ups, die-cuts, and various eye-catching devices to boost drink sales.

Despite the Depression, restaurants and related entertainment flourished throughout the 1930s, creating a golden age in menu design.

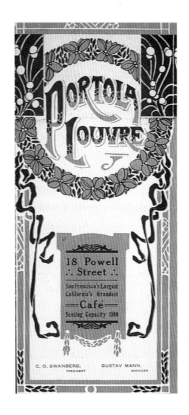

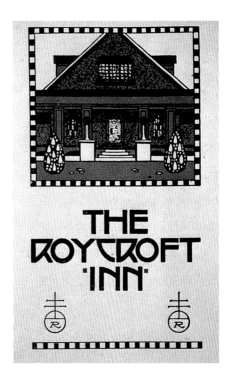

Top. Art Nouveau decorations enhance this fold-out menu from the Portola Louvre Restaurant in San Francisco, which held 1,500 customers. December 23, 1913. *Bottom.* Graphics inspired by the Vienna Secession grace this simple menu from the Roycrofts' compound in Aurora, New York, July 25, 1921.

Cafeterias, drive-ins, lunch counters, lounges, supper clubs, and nightspots popped up everywhere. Themes ran the gamut from Colonial to Buccaneer, from jungle to Persian palace, and from cornball steak house to elegant dining pavilion. Several expositions and world fairs during the thirties provided showcases for restaurant innovation. Their menus were often showstoppers.

Progress in printing, photography, and especially color photography, opened up more opportunities for creative expression. Photography had had limited appeal until the late thirties because of poor reproduction quality and the perception that it was an industrial art. Fine art photographers such as Alfred Steichen and Paul Outterbridge changed that perception by producing sophisticated images for advertising. Photos became another option for menu designers though their use never dominated imagery as illustration and typography did.

Pre-war restaurant business in the 1940s continued in full swing, but once the United States entered World War II, shortages appeared and rationing affected the business. Despite these difficulties, restaurants continued to function, proudly displaying a renewed patriotism on menu covers. The war years also saw graphic innovations introduced in the thirties beginning to be assimilated in menu art. Elaborate decoration began to give way to modernist principles of simplification.

Once victory was achieved, eating out

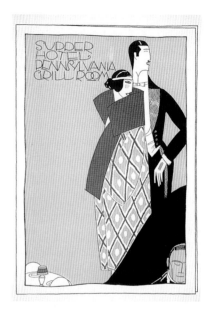

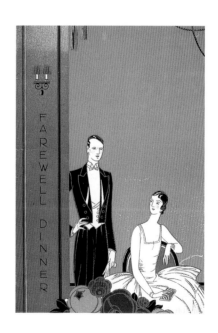

Two menus in classic Art Deco style reflect the elegance of 1920s dining. *Top.* Hotel Pennsylvania, c. 1925. *Bottom.* Ship menu, S.S. *Minnetonka*, c. 1920.

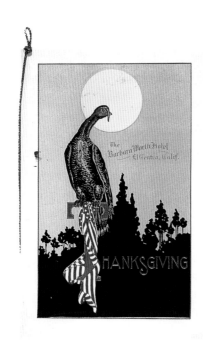

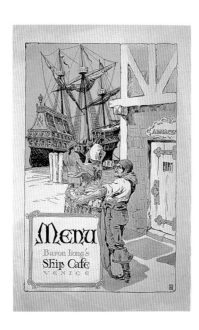

Top. Embossed and gold stamped, this commemorative menu dated November 28, 1918 exemplifies the simplicity of poster style graphics. Barbara Worth Hotel, El Centro, California. *Bottom.* This menu from the Ship Cafe, a popular spot with silent film stars, was a smart example of elegant twenties graphics, c. 1917.

boomed. Several key factors after the war changed American dining habits: Americans were increasingly mobile and anxious to pursue the adventures of the road now that gas rationing had ended; suburbs flourished, and casual was a preferred lifestyle. Restaurateurs found that in this post-war period, good help was hard to find while increases in expenses and growing competition necessitated budget trimming. The trend toward self-service outlets that eliminated many of those factors grew, and diners began to patronize what were called "fast-food" stands.

New images of atomic power and space travel became visual elements in the early fifties. Menus soon sported stars and planets, and typography took off in highly stylized directions. Primary and bright colors of previous decades were replaced by a subdued palette that favored colors such as forest green and American Beauty red. A prime user of these menu graphics was the increasingly popular free-standing coffee shop. Coined "Googie," after a Southern California coffee shop, most of these restaurants were designed in a futuristic and nonconformist manner. These "way out" restaurants and atomic age graphics were a perfect match.

Despite the rise of casual dining and fast-food outlets, there were plenty of new venues for creative menu design. Specialized restaurants that featured a singular item such as pizza, steak, or pancakes flourished throughout the United States. Many catered to families. The kid's menu, although not a new invention, was a

gimmick that appealed to youngsters, who felt they were getting special attention. Theme restaurants added to the number of dining choices in the late fifties. These restaurants could be elegant or commonplace. The menu at the Twelve Caesers, one of New York's grand style dining rooms that attempted to recreate the cuisine of Imperial Rome, was a massive hulk of bleached parchment complete with purple ribbon and waxed seal embossed with the head of the emperor. A Polynesian craze, which erupted around the same time Hawaii was granted statehood, resulted in dozens of grass shacks and tiki-inspired cafes and restaurants. Menu covers sported hula girls, palm trees, and tapa cloth motifs that had been the staple of South Seas cafes since the twenties. Resort destinations such as Miami and Las Vegas and theme parks such as Disneyland and Knott's Berry Farm in California were other obvious locations for theme restaurants.

The restaurant industry felt the full effect of fast-food restaurants in the 1960s. Additionally, singles bars, chain restaurants, and membership clubs substituted for more traditional restaurants. As restaurant dining changed, so too did the inspiration for innovative graphics. As the sixties progressed, imagination and creativity were less evident in restaurant graphics. The inspiration of Pop art, a revival of twenties nostalgia, and the flowering of hippie images provided some stimulus in an otherwise monotonous era.

Inspired in part by television programming and by a heightened awareness of all that was camp and kitsch, menus from a variety of period revival restaurants featured vintage line art from late-eighteenth- and nineteenth-century sources. Other decorative devices such as Tiffany lamps, wood typefaces, stained glass, and Art Nouveau stylings were also used on menus. Adding to the small creative blip in an otherwise stagnant industry were several restaurants that successfully translated the psychedelic poster tradition into menu covers. Although a temporary diversion in both gourmand and graphic circles, these restaurant menu graphics were reflective of late sixties popular arts.

By the end of the 1960s, the restaurant business continued to thrive on certain levels, but

Assorted seafood and twenty-six differently prepared oysters highlighted this menu from the Submarine Sea Food Restaurant in Chicago, c. 1916.

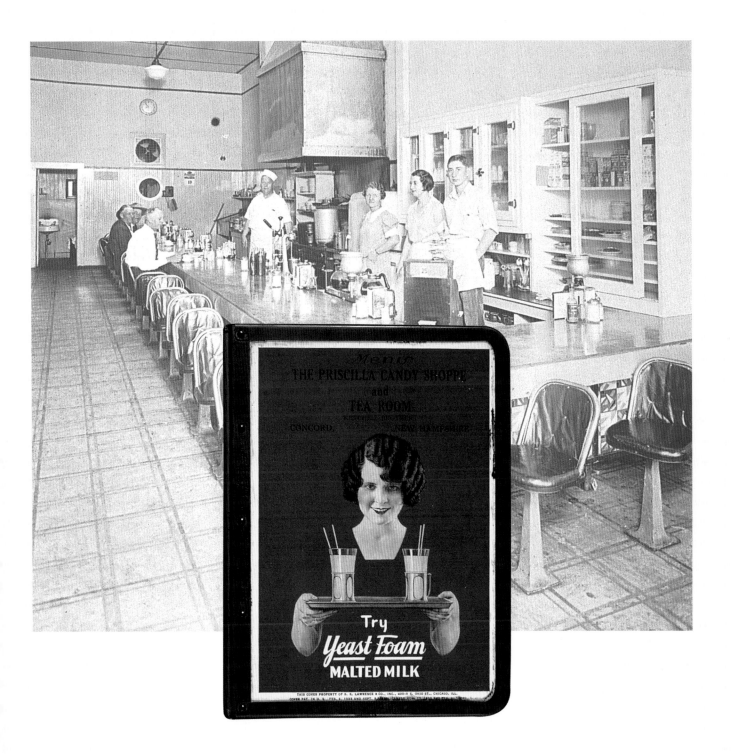

it wasn't the powerhouse it had been in the past. Eventually, a new generation of affluent diners would create a renewed demand for eating out. As this came about, the menu would again take center stage in the marketing of a restaurant. These glory years of menu design provided the American public with a pleasing prelude to the dining experience, inadvertently creating a depository of informal visual and popular history. Many designs continue as valid graphic statements, while others are tethered to their moment in time. Regardless, they continue to be a source of inspiration, documenting America's affair with eating.

A metal frame encases this beautiful example of a stock menu advertising Yeast Foam Malted Milk for the Priscilla Candy Shoppe and Tea Room, Concord, New Hampshire, c. 1925.

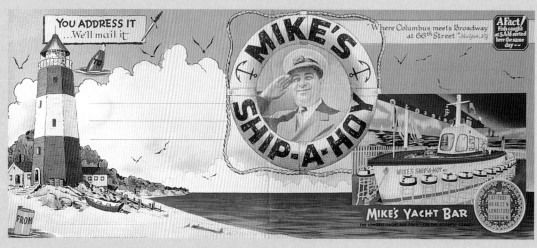

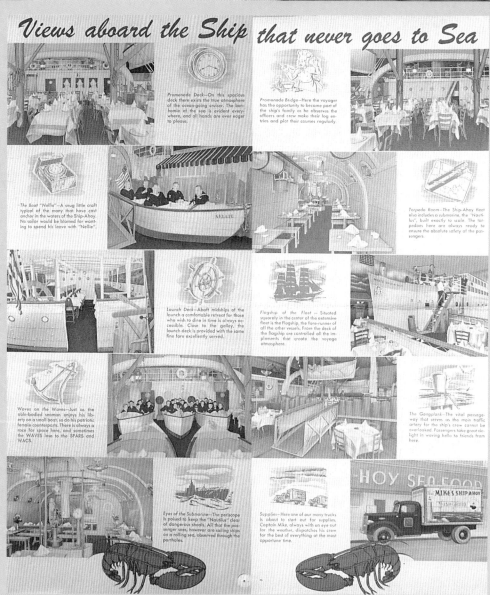

Above. This menu from Mike's Ship-A-Hoy restaurant has many features prized by collectors. Oversized with fine illustrations and hand-tinted photos, it unfolds to reveal a massive list of food items, c. 1945. *Opposite top.* Black Americana, collected for its limited availability and dated racial stereotypes, is exemplified in these two menus which featured similiar artwork for restaurants a continent apart, c. 1941. *Opposite bottom.* This set of menus from the Tam O' Shanter restaurant in Los Angeles shows the stylistic range of four decades of the restaurant's history. Collecting a sequential set of menus for a particular restaurant is a popular pursuit for menu enthusiasts.

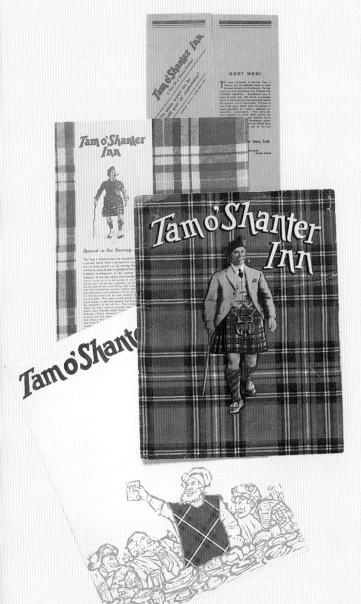

Collecting Menus

Collecting menus has been a popular pastime for generations of diners. Taking a restaurant menu was a way of preserving a memory or documenting a trip or voyage. Many restaurants provided customers with souvenir versions of their menus. These could be scaled-down facsimiles or specially printed "take-home" menus that served as advertisements. These menus often ended up in scrapbooks or drawers or were tossed away as their personal value diminished. Others were collected for their historical or culinary value.

The condition of a menu is not necessarily a reflection of its value. Age, rarity, aesthetics, and personal collecting focus are factors that can also determine the price. Stains, autographs, personal notations, and other "flaws" aren't always an indication of an undesirable menu. A used menu can often be valuable even if items have been scratched out and written over.

Because many menus were saved as souvenirs and preserved in scrap books they may still have glue on their reverse side. This isn't the most desirable condition, but unless the paper is torn or the menu mutilated, it may still retain its value. Folds are also a problem resulting from large menus being bent for storage purposes. This also detracts from their appearance but may not necessarily diminish their merit.

For the most part, menus from the twentieth century, with the exception of pre-1920 and select commemorative menus, are still affordable. Menus reflecting regional preferences, or those associated with well-known restaurants, movies, or expositions may command higher prices, but in general vintage menu collecting is an inexpensive hobby. Some consistent sources of vintage menus are flea markets, swap meets, antique stores, specialized paper ephemera shows, garage sales, and estate sales. These venues inevitably produce old menus, but some of the best finds are encountered in the least expected places. Expanding the "hunt" is the best way to complete a collection.

Several large menu collections are available for research or viewing. Among them are The New York Public Library (holdings here are mostly from the turn of the century), The California State Library (a broad spectrum of California dining experiences), The Los Angeles Central Public Library Department of Special Collections (an extensive collection of local dining establishments mostly from the twentieth century), and the Culinary Institute Library. Check with each of the collections for their hours and viewing policies.

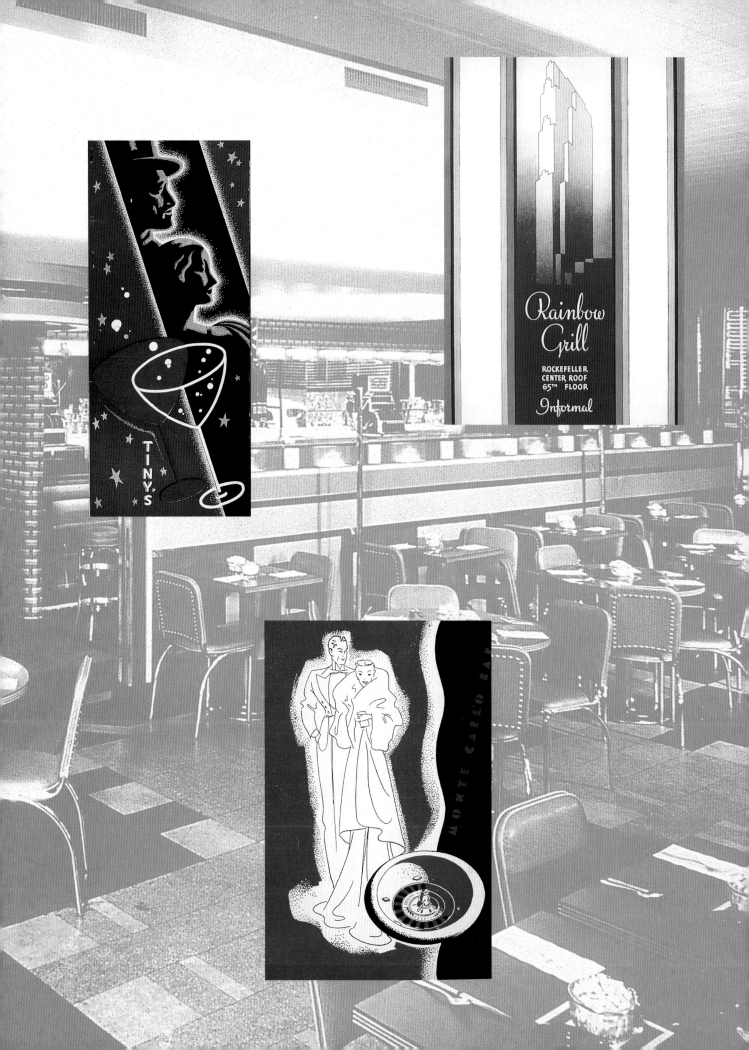

he thirties really began with the collapse of the Stock Market in 1929 and ended with America's entry into World War II on December 7, 1941. These two events bracket over ten years of dining that saw the restaurant industry grow by tremendous strides.

The evolution from an agrarian to an industrial base, the population shift from rural to urban areas, and the steady rise of ownership of affordable automobiles increased dining outside the home throughout the thirties, and despite the economic hardships of the Depression, the restaurant business prospered. In cities and on the road, people were eating out more than ever. A 1934 guidebook noted there were more than 18,000 restaurants in New York City alone. In 1936 Duncan Hines published his *Adventures In Good Eating: A Directory of Good Eating Places along the Highways and in Villages and Cities of America*. By 1939 it had reached the best-seller lists, further confirming that restaurants and interest in food were reaching new heights.

For the most part, menu covers of the thirties continued established

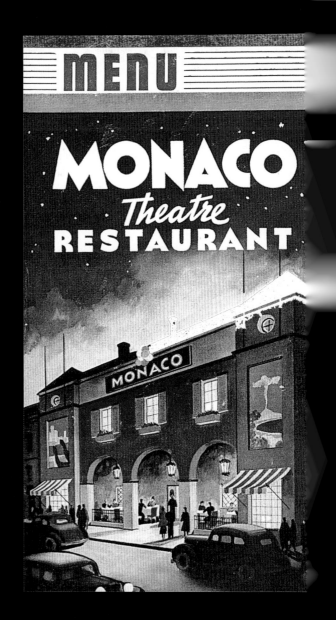

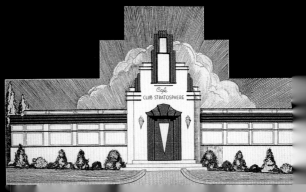

Left. Menus from Tiny's, the Rainbow Grill, and the Monte Carlo Casino are prime examples of '30s high-style. *Top*. The menu for the Monaco Restaurant Theatre, c. 1938, in San Francisco featured a colorful period rendition of the restaurant's exterior. *Bottom*. A pristine die-cut Art Deco building doubled as souvenir menu/post card for The Club Stratosphere ballroom, c. 1935, in Everett, Washington.

themes. Graphics appropriate to a restaurant's location, motif, or cuisine were logical images. During the decade, several stylistic movements influenced design.

One clear break from the Art Deco designs of the twenties was the implementation of European design theory, which emphasized minimalism and clear, legible type. These elements were slow to filter down to commercial applications such as menus, but the paring down of decoration on covers was evident as the decade progressed. The concept of streamlining, introduced in the industrial arts where it was developed, also took hold in the 1930s and was enthusiastically applied to menu design. Speed dictated these graphics, and the reduction of elements reinforced images of cleanliness and sanitation. There was also something very up-to-date and modern conveyed with streamlining, and this concept, too, was eagerly pursued by many restaurants. The "fancy" restaurant reemerged from the Depression, catering to a small elite who could afford places such as New York's 21 and Hollywood's Trocadero. Menu design for such establishments remained simple and sedate, reflecting an understated elegance. Menu size became an important factor as more items were added. Being handed an oversized bill of fare became an event in itself, subtly suggesting a restaurant's importance by the seemingly endless choices offered to a customer. As more and more Americans took to the highway, drive-ins and roadside restaurants proliferated, opening up a whole new area of restaurant experience that catered to an increasingly mobile public. Here, menu design embraced new styles and bold graphics.

Right. Art Deco–inspired graphics grace this group of classic 1930s menus. *Opposite.* Many 1930s night spots featured scantily clad damsels, revealing the era's sophisticated elegance. Paradise Cabaret Restaurant, New York, 1935. Club LaSalle, Los Angeles, c. 1934. Hotel Astor, New York, c. 1936. Cafe des Artistes, New York, c. 1939.

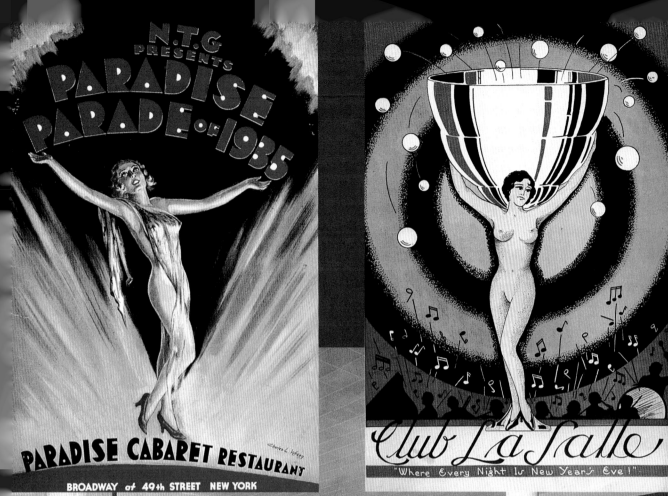

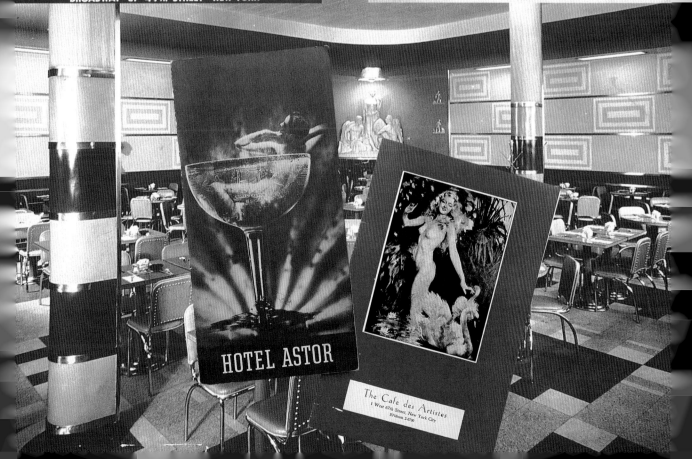

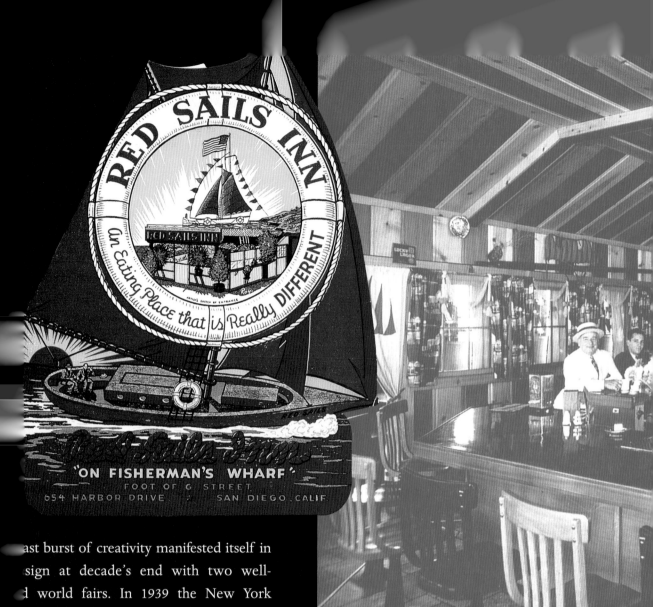

ast burst of creativity manifested itself in
sign at decade's end with two well-
d world fairs. In 1939 the New York
air and the Golden Gate Exposition at San
's Treasure Island opened. The fairs
d up-to-the-minute architecture and
To feed the visitors, the expositions hosted
ble restaurants, many with sumptuous
strations reflecting foreign pavilions and
ds. The Trylon and Perisphere, symbols
w York Fair, were applied to many of the
signs. Similarly, at the Treasure Island
, the Tower of the Sun was a popular
a grand show of civic pride, hotels and
ts in both host cities featured special
ers in tribute to the fairs.

war evident in Europe and Asia as the
led, the restaurant industry would see a
activity soon to diminish as the United

States became engaged in the world conflict. The
next decade would curb American eating habits for
the duration of the war, but a whole new menu
category would be born as the concept of fast food
was introduced in the latter part of the forties.

Top. The menu of the Red Sails Inn, San Diego, c. 1938, is a visual
delight with its vivid colors and unusual shape. *Opposite top.* Paul's
Ship-a-Hoy Cafe in Hollywood, c. 1933, featured a special seven-
course "surf" dinner for 75 cents. *Opposite bottom.* A trio of West
Coast fish houses featured fanciful seafood illustrations. Pop Ernest,
Monterey, California, c. 1934, illustrated by Jo Mora. Bernstein's Fish
Grotto, San Francisco. Both c. 1936.

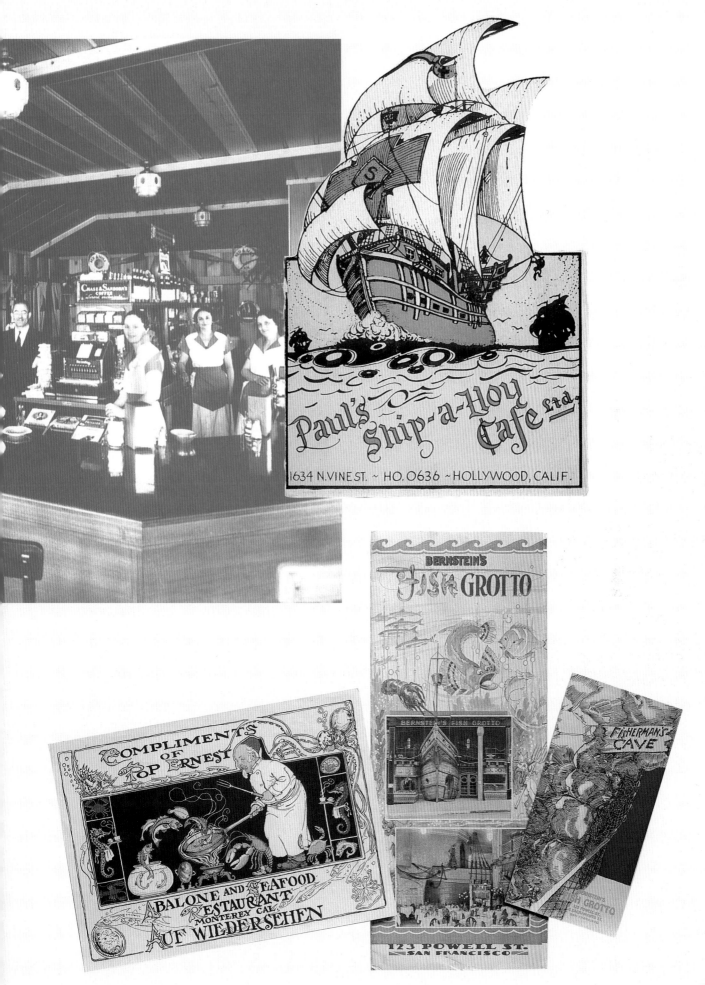

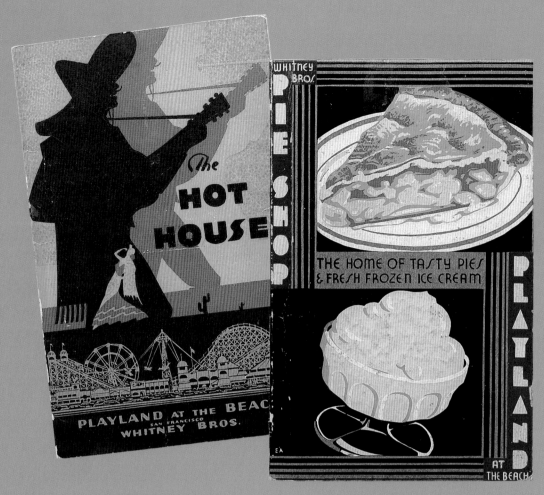

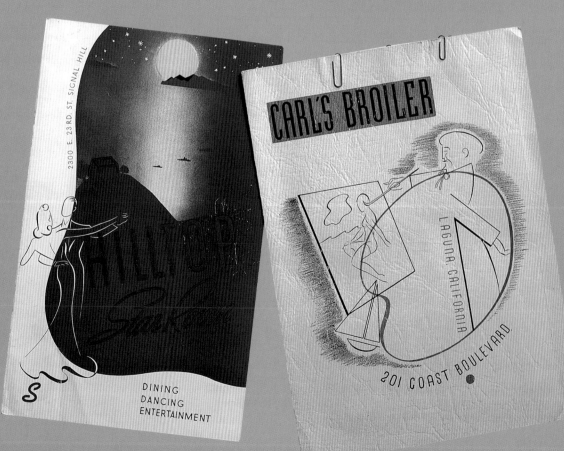

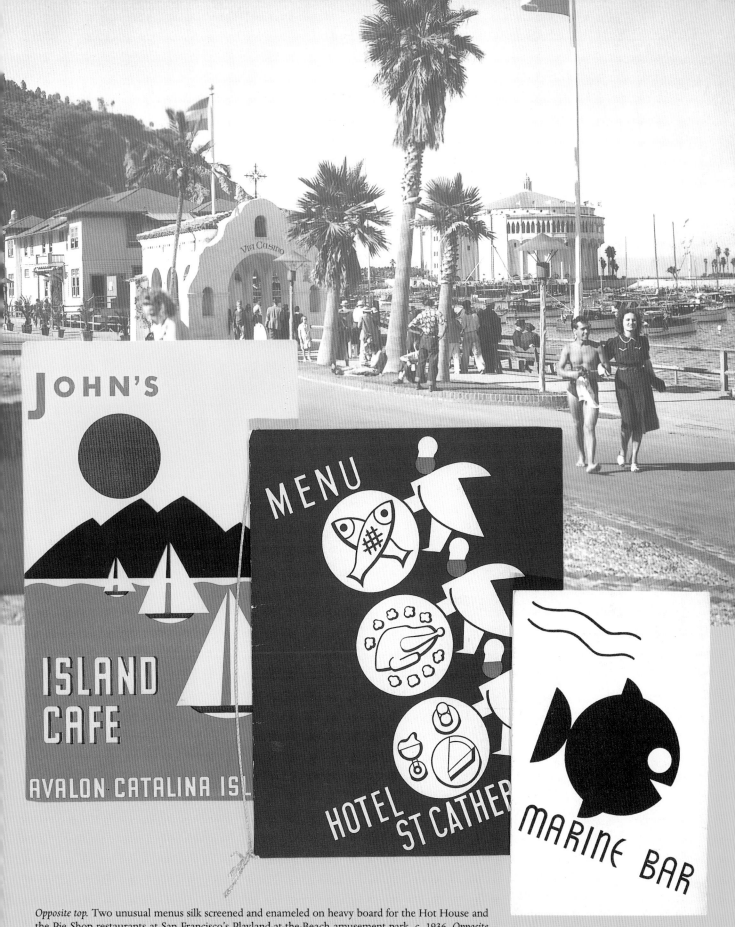

Opposite top. Two unusual menus silk screened and enameled on heavy board for the Hot House and the Pie Shop restaurants at San Francisco's Playland-at-the-Beach amusement park, c. 1936. *Opposite bottom.* An airbrush wonder for the Hilltop nitery in Signal Hill, California, c. 1939. A stylized painter is the clever graphic for Carl's Broiler in the art colony of Laguna Beach, California, c. 1938. *Above.* Graphic simplicity makes these menu covers, designed by Dorothy and Otis Sheperd, standouts for Catalina, the island resort off the Southern California coast, c. 1935.

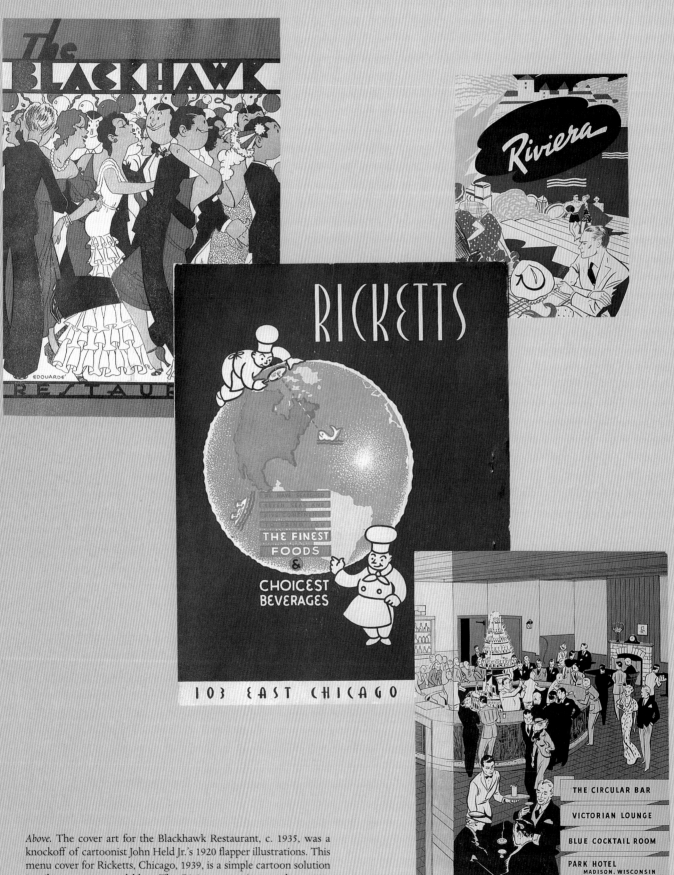

Above. The cover art for the Blackhawk Restaurant, c. 1935, was a knockoff of cartoonist John Held Jr.'s 1920 flapper illustrations. This menu cover for Ricketts, Chicago, 1939, is a simple cartoon solution in vibrant orange and blue. The Riviera menu/postcard, c. 1939, effectively used the flat stylings of poster art. The cocktail menu for the circular bar in the Park Hotel in Madison, Wisconsin, c. 1936, is a model of descriptive architectural graphics.

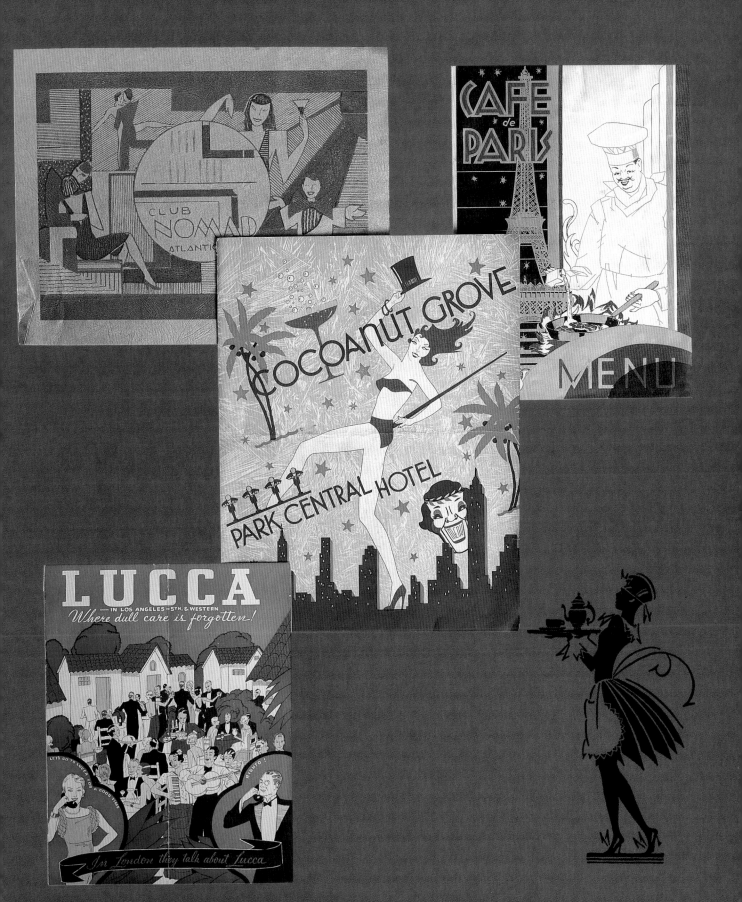

Above. A broad range of typical 1930s menu art is displayed on the covers of the Club Nomad, Atlantic City, c. 1936, the Cafe de Paris, c. 1935, the Cocoanut Grove, Park Central Hotel, New York, c. 1938, and Lucca's, Los Angeles, c. 1937.

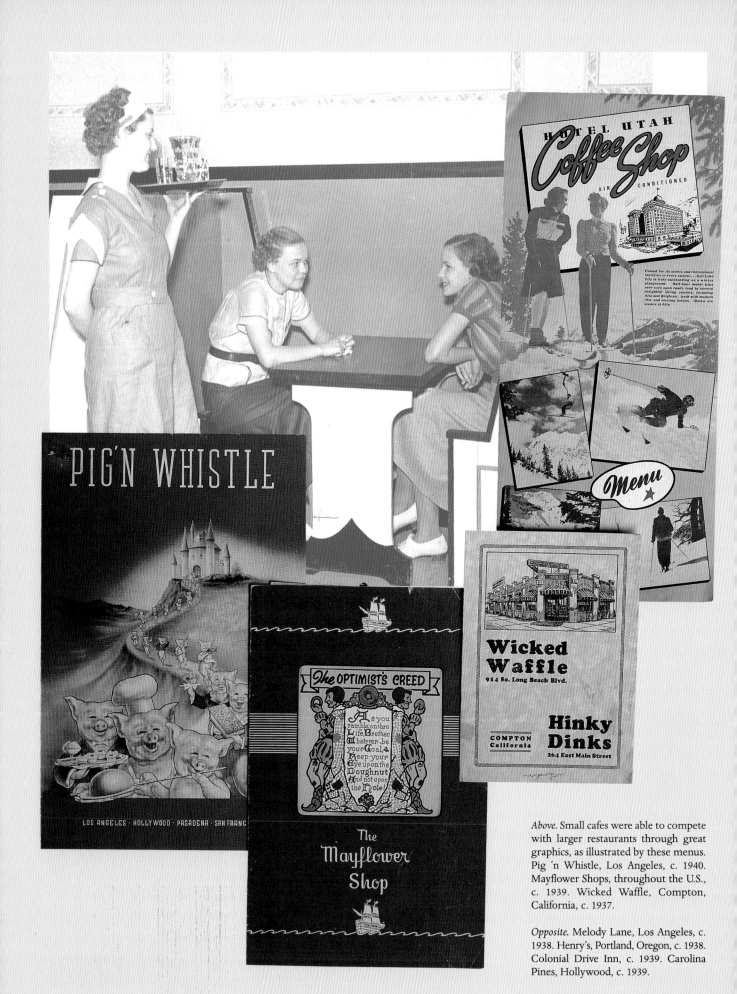

Above. Small cafes were able to compete with larger restaurants through great graphics, as illustrated by these menus. Pig 'n Whistle, Los Angeles, c. 1940. Mayflower Shops, throughout the U.S., c. 1939. Wicked Waffle, Compton, California, c. 1937.

Opposite. Melody Lane, Los Angeles, c. 1938. Henry's, Portland, Oregon, c. 1938. Colonial Drive Inn, c. 1939. Carolina Pines, Hollywood, c. 1939.

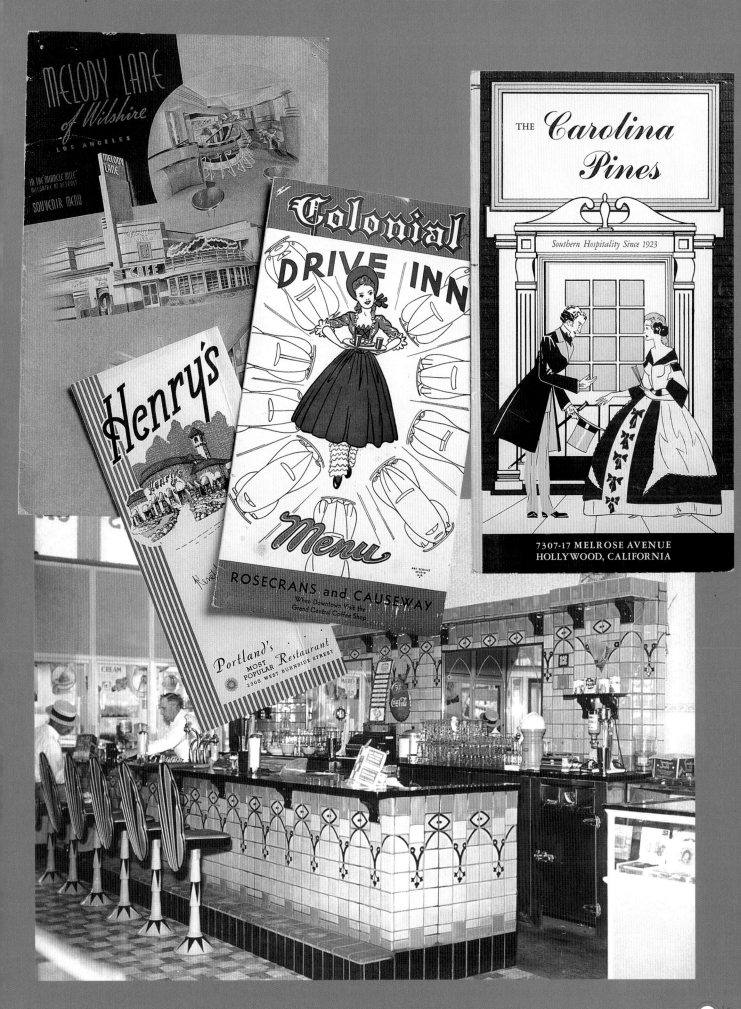

MELODY LANE
of Wilshire
LOS ANGELES

IN THE MIRACLE MILE
WILSHIRE AT DETROIT

SOUVENIR MENU

Henry's

Colonial
DRIVE INN
Menu

ROSECRANS and CAUSEWAY
When Downtown Visit the
Grand Central Coffee Shop

ART SERVICE
STUDIO
S.D.

THE Carolina
Pines

Southern Hospitality Since 1923

7307-17 MELROSE AVENUE
HOLLYWOOD, CALIFORNIA

Portland's MOST POPULAR Restaurant
2305 WEST BURNSIDE STREET

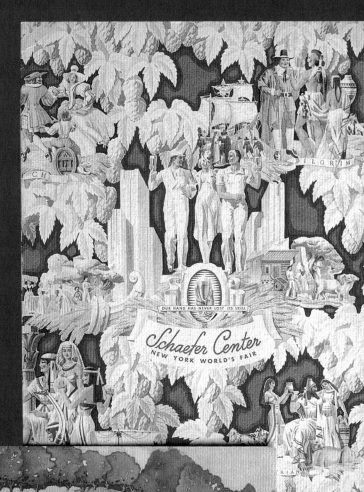

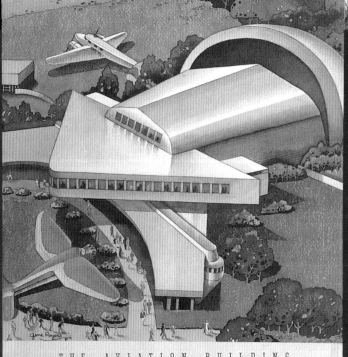

Menus celebrating the New York World's Fair of 1939–40 illustrate a high-water mark in menu design. Sophisticated graphics combined with dynamic fair imagery make these menus prized. Blue Room, Hotel Lincoln, New York, c. 1938. Schaefer Center, c. 1939. La Guardia Field Restaurant, New York, c. 1939. *Opposite.* Childs Pavilion, c. 1939. Hotel New Yorker, c. 1939. Rheingold Inn, c. 1939.

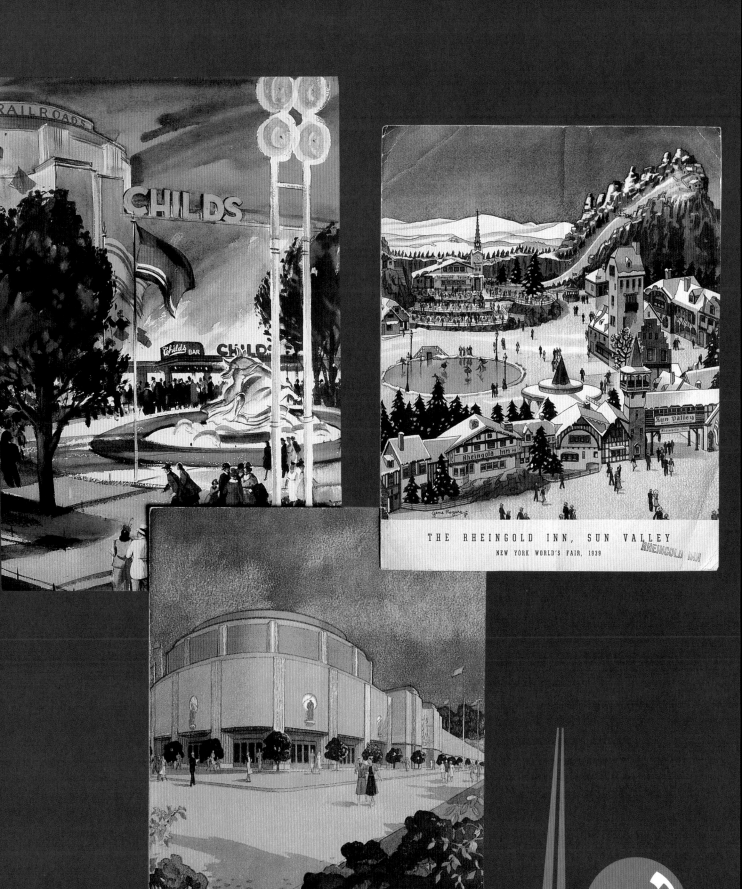

THE RHEINGOLD INN, SUN VALLEY
NEW YORK WORLD'S FAIR, 1939

THE RAILROAD BUILDING
NEW YORK WORLD'S FAIR, 1940

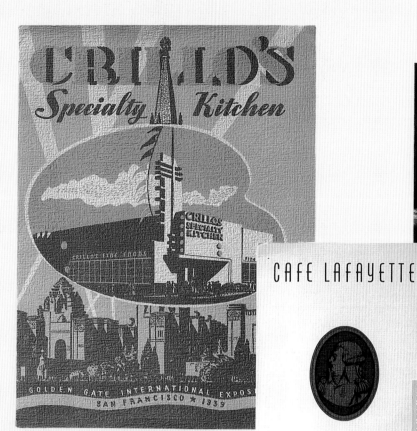

CRILLO'S
Specialty Kitchen

CRILLO'S FINE FOODS

GOLDEN GATE INTERNATIONAL EXPOS.
SAN FRANCISCO ★ 1939

WHITE ★ STAR
RESTAURANT
Jack Springer

CAFE LAFAYETTE

PALAIS de l'ELEGANC.
GOLDEN GATE INTERNATIONAL EXPOSITION
TREASURE ISLAND ★ SAN FRANCISCO ★ 193

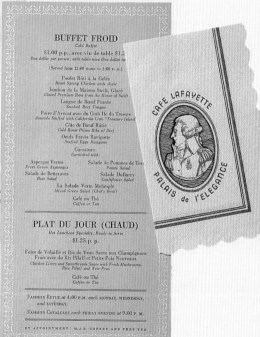

BUFFET FROID
Cold Buffet
$1.00 p.p., avec vin de table $1.2.
One dollar per person; with table wine One dollar tw

(Served from 12:00 NOON to 3:00 P. M.)

Poulet Rôti à la Gelée
Roast Spring Chicken with Aspic
Jambon de la Maison Swift, Glacé
Glazed Premium Ham from the House of Swift
Langue de Bœuf Fumée
Smoked Beef Tongue
Poire d'Avocat avec du Crab Ile du Tresore
Avocado Stuffed with California Crab "Treasure Island"
Côte de Bœuf Rôtie
Cold Roast Prime Ribs of Beef
Oeufs Farcis Ravigotte
Stuffed Eggs Ravigotte
Garniture:
Garnished with:
Asperges Vertes Salade de Pommes de Ter
Fresh Green Asparagus *Potato Salad*
Salade de Betteraves Salade DuBarry
Beet Salad *Cauliflower Salad*
La Salade Verte Melangée
Mixed Green Salad (Chef's Bowl)
Café ou Thé
Coffee or Tea

PLAT DU JOUR (CHAUD)
Hot Luncheon Specialty, Ready to Serve
$1.25 p. p.

Foies de Volaille et Riz de Veau Saute aux Champignons
Frais avec du Riz Pilaff et Petits Pois Nouveaux
Chicken Livers and Sweetbreads Saute with Fresh Mushrooms,
Rice Pilaff and New Peas
Café ou Thé
Coffee or Tea

FASHION REVUE at 4:00 P.M. each MONDAY, WEDNESDAY,
and SATURDAY.

FASHION CAVALCADE each FRIDAY EVENING at 9:00 P. M.

BY APPOINTMENT: M.J.B. COFFEE AND TREE TEA

CAFE LAFAYETTE
PALAIS de l'ELEGANCE

HOSPITALITY SERVICE CARD

CALIFORNIA WINES

"Bacchus,
Crowning
the Vintner"

Food & Beverage Palace
Golden Gate
International Exposition

**WINE TEMPLE
EXHIBITORS**
(FOOD & BEVERAGE PALACE)
TREASURE ISLAND • CALIFORNIA

The 1939 Golden Gate Exposition in San Francisco produced many menu standouts. Among them were Crillo's Specialty Kitchen, Cafe Lafayette, which featured French delicacies, the White Star Restaurant specializing in tuna and Kraft cheese sandwiches, and the Food and Beverage Palace, which showcased California wines.

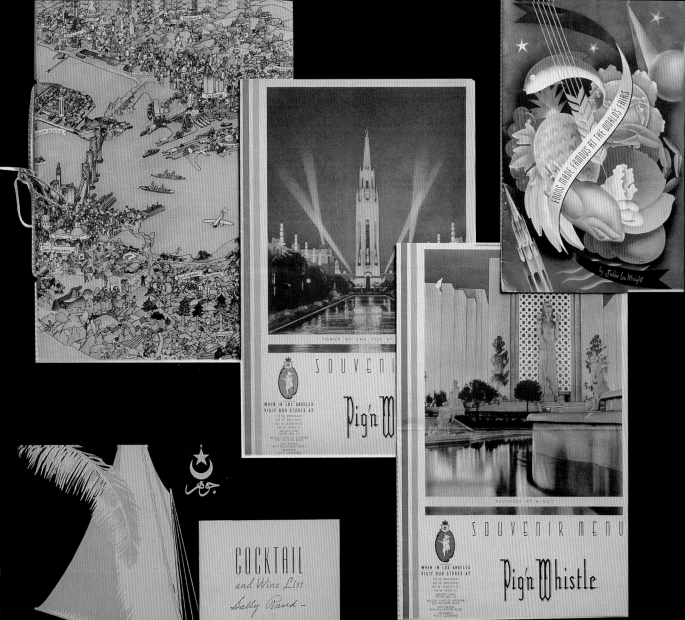

TOWER OF THE SUN AT

SOUVENI...

WHEN IN LOS ANGELES
VISIT OUR STORES AT
712 SO. BROADWAY
646 SO. BROADWAY
607 W. SEVENTH ST.
316 W. SIXTH ST.
740 SO. HILL ST.
MELODY LANE OF WILSHIRE
5151 WILSHIRE BLVD.
HOLLYWOOD
6174 HOLLYWOOD BLVD.
PASADENA
412 E. COLORADO

Pig'n W...

FOODS MADE FAMOUS AT THE WORLD'S FAIRS

by Julia Lee Wright

PACIFICA AT NIGHT

SOUVENIR MENU

WHEN IN LOS ANGELES
VISIT OUR STORES AT
712 SO. BROADWAY
646 SO. BROADWAY
607 W. SEVENTH ST.
316 W. SIXTH ST.
740 SO. HILL ST.
MELODY LANE OF WILSHIRE
5151 WILSHIRE BLVD.
HOLLYWOOD
6174 HOLLYWOOD BLVD.
PASADENA
412 E. COLORADO

Pig'n Whistle

COCKTAIL
and Wine List
Sally Rand –

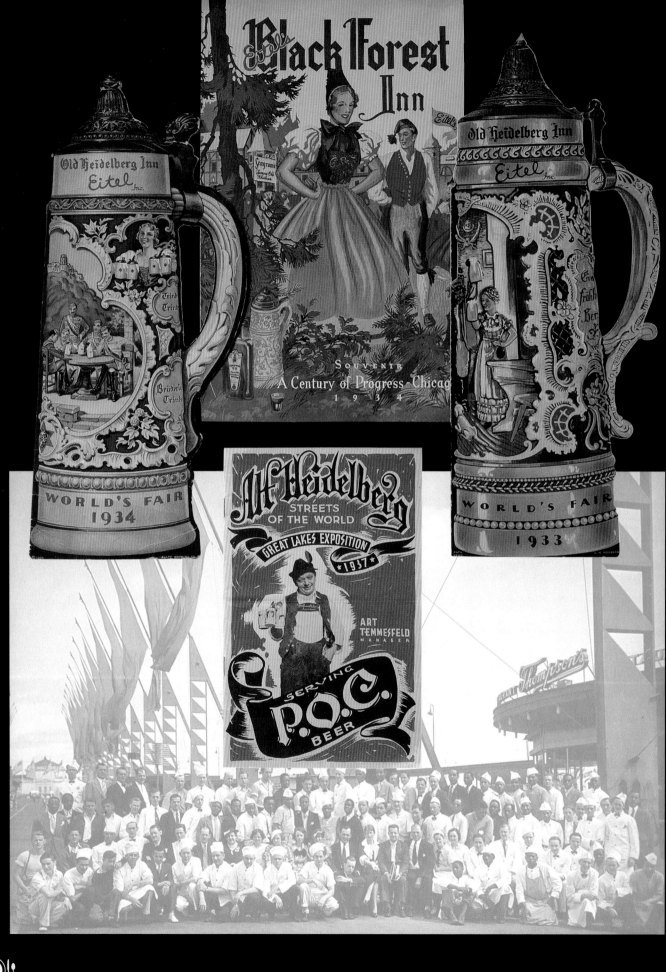

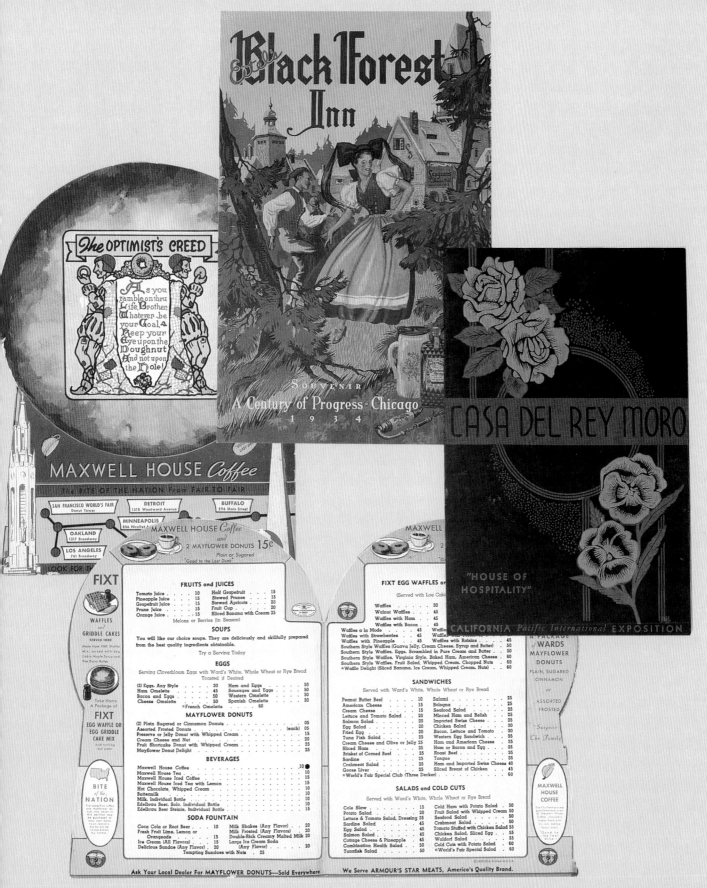

Opposite. Two beer stein menus from Chicago's Century of Progress, 1933–34, frame a menu from The Black Forest Inn, another German restaurant at the exposition. *Opposite bottom.* The Alt Heidelberg menu from the Great Lakes Exposition of 1937 included a songbook of German favorites.

Above. A donut-shaped menu for the Mayflower Donut Shops found at both the New York and San Francisco fairs. Another version of the popular Black Forest Inn at the Chicago exposition. An understated menu for the Casa Del Rey Moro restaurant at the California Pacific International Exposition in San Diego, 1935.

MENU
Emmadine
FARMS INC.
ICE CREAM

OUR MENU
Flavor of Distinction
HONEYMOON
PINEAPPLE COCOANUT and CHERRY
Goldenmoon Products

WE SERVE THIS
Thrilling
TASTE - TREAT

OXFORD SWEETS
Menu

Eat *Breyers* all-ways
ICE CREAM

Consistently Superior Since 1866

HOMEFRONT TO BABY BOOM
Menus of the 1940s

Until the bombing of Pearl Harbor and the United States' entry into World War II, restaurants had been doing record business. Economic stability, regained in the late thirties, put money in the average American's pocket, and "special occasion" dining became more common. Drive-ins, cafeterias, diners, and luncheonettes made a casual meal affordable, and Americans ate out frequently.

The war changed everything overnight. The rationing of food and building materials meant certain items were unavailable, which meant that new building was curbed, though not eliminated, slowing down the expansion of chain restaurants and the remodeling of others. Still these shortages appeared to be more of an inconvenience than an assault on the eating habits of U.S. citizens. A look at a drugstore luncheonette menu from mid-1942 reveals an amazing array, including filet mignon, lamb chops, halibut steak, kadota figs, and fresh strawberry shortcake. Also in apparent abundance were seemingly hard-to-get items such as creamery butter and

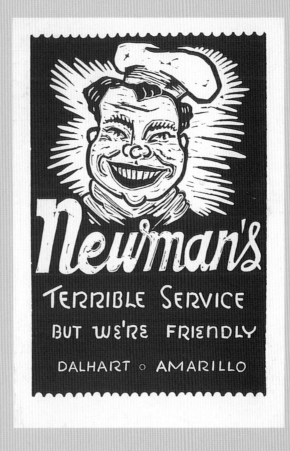

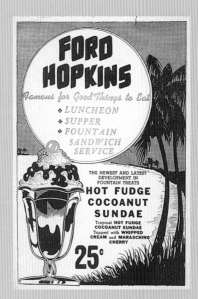

Left. Hundreds of small-town drugstore fountains relied on stock covers for their menu identity. *Top.* Newman's cafe in Dalhart and Amarillo, Texas, mixed humor and a striking woodcut to create a top-notch menu. *Bottom.* A tempting hot fudge sundae is the focus of the menu from Ford Hopkins's luncheonette, c. 1948.

coffee. Fine restaurants also seemed unfazed by wartime allotments, as menus from places such as the Brown Derby in Hollywood continued to offer their celebrity clientele a rich assortment of comestibles. Available were luxuries such as California lobster on brochette, fresh Belgian squab sauté, fried eggplant, and a Chinese dish, Chew Kai Kew. The restaurants were meatless on Tuesdays and Fridays, a patriotic nod to the "Share the Meat" program.

Following the war, restaurants experienced rapid growth. Returning servicemen and war workers with new families created a demand in restaurant eating that surpassed pre-war numbers. Increased mobility also put huge numbers of people on the road and restaurants expanded to meet the demand. In the late forties, quick meals were introduced as speed and efficiency became hallmarks of an industry forever catering to a fickle public. Self-service and drive-through outlets became increasingly popular as Mom, Pop, and the kids watched budgets and had less time to sit down and eat. The need for a paper menu was eliminated with restaurants offering limited items, but there were still plenty of outlets for creative menu design.

The look of the menu cover, in the first two years of the forties, followed many of the design directions of the late thirties. Familiar and conventional images graced many of the covers, but the modernist movement introduced by émigré European designers in the early thirties was beginning to be felt and implemented by the American design community. Again, the applied arts lagged behind the advertising and design world, but the elimination of decoration and the use of integrated type appeared on more and more menus as the decade progressed. The influence of surrealism was noticeable also, first appearing on the covers of Vogue and Harpers Bazaar, and later on menus. Stylized versions of baroque, early American, and Victorian influences also popped

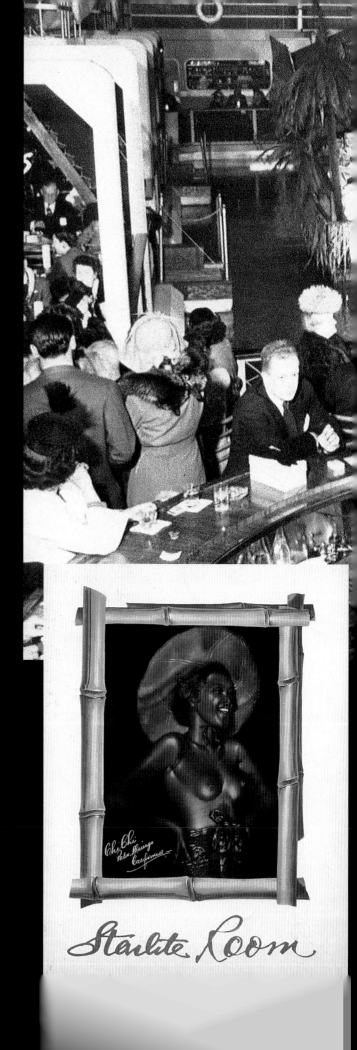

Chez Chi
Palm Springs
California

Starlite Room

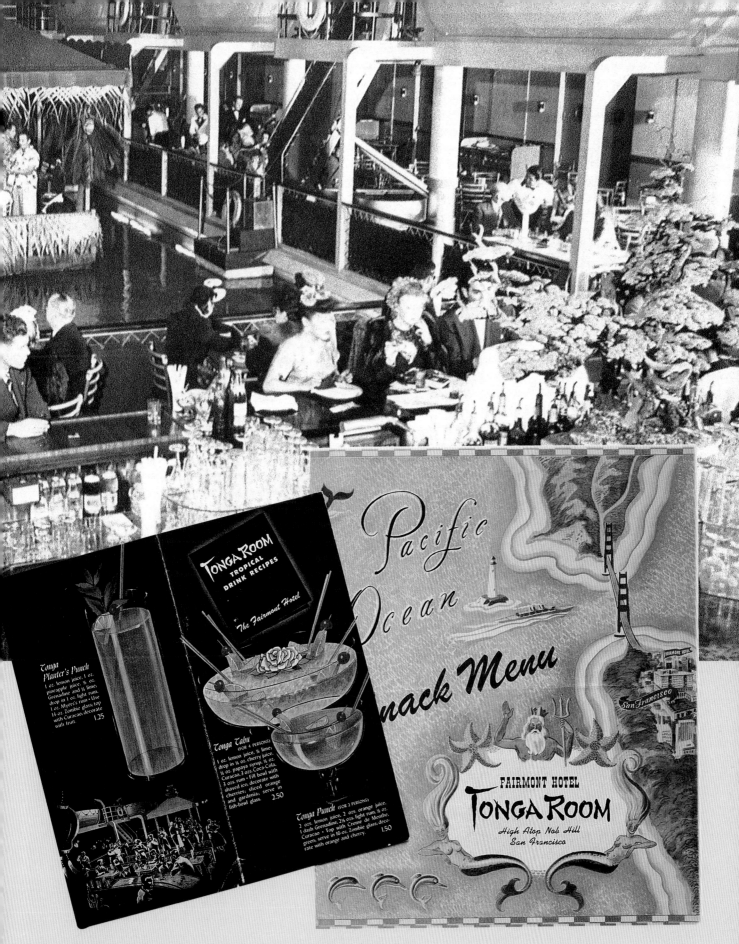

Opposite. A topless Tahitian strikes a provocative pose on the menu of the ChiChi restaurant's Starlite Room in Palm Springs, c. 1949. *Above.* Servicemen and civilians flocked to the Fairmont Hotel in San Francisco during World War II for a taste of the tropics. Tonga Room snack menu and drink recipe booklet, c. 1945.

up with regularity, in decorative opposition to minimalist modernism. The war years produced a range of patriotic covers in red, white, and blue. V's for Victory, wind-swept flags, and proud eagles abounded. After war's end conservative treatments gave way to more adventurous designs with a perceptible change of palette from bright colors to more subdued tones and images. Hard-edged modernism replaced streamlined curves changing to more abstract shapes, paralleling developments in architecture and fine art.

The introduction of fast-food outlets in the late forties eliminated the standard printed menu, but the developing popularity of freestanding coffee shops filled that void with vibrant cover designs to match their exaggerated architecture. The introduction by airlines of in-flight meals in the late thirties created a need for special menus. Flying was

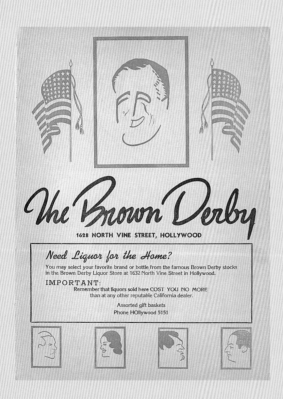

Above. The Brown Derby saluted the war effort by including American flags and a portrait of F.D.R. on its menu cover, c. 1945. *Center.* Restaurants displayed their patriotism in numerous ways as these various red, white, and blue menus clearly demonstrate. *Opposite right.* A menu from Headquarters, c. 1946, conceived by returning G.I.s John Schwarz and Marty Snyder, which featured their experience as head mess chefs for Dwight D. Eisenhower.

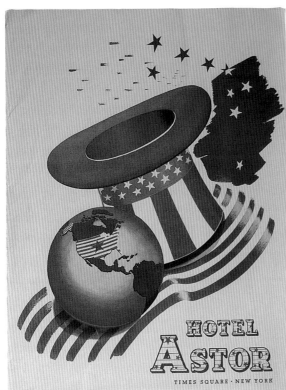

still considered a luxury, and airline menus reflected a certain elegance.

Several design trends mark the period. Script type, a carryover from the previous decade, was a staple, with the lettering sometimes being the only element expressed. Airbrushing, a technique that was widely used in the late forties and early fifties, eventually lost its popularity with overuse. Photographs for menu covers were more common with advancements in printing and color technology. Menu covers might range from pristine studio studies to stock shots of landscapes, animals, or buildings both in black and white and in color.

The forties closed with a bright outlook for the restaurant industry. The habit of eating out, even just once a week, was becoming comfortable for an increasing number of Americans, and the promise of a healthy future for food purveyors seemed secure.

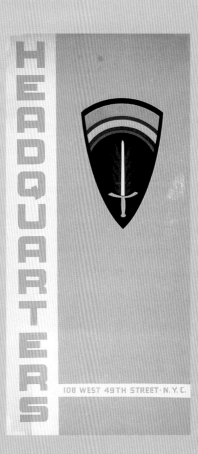

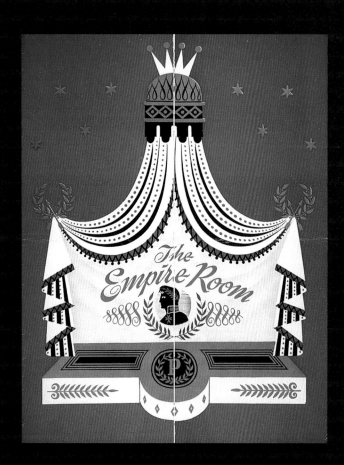

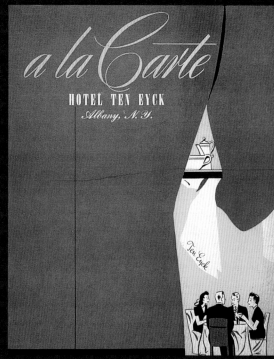

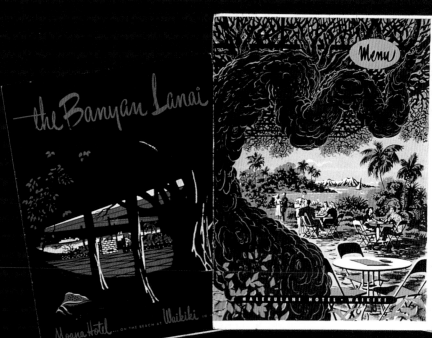

A stylistic shift was apparent in these late 1940s menus. Subdued colors combined with baroque and surrealistic elements were their hallmark. *Top*. Empire Room, Palmer House, Chicago, 1947. Hotel Ten Eyck, Albany, New York, c. 1949. *Bottom*. The Banyan Lanai, Waikiki, Hawaii, c. 1949. Halekulani Hotel, Waikiki, Hawaii, c. 1949. Niumalu Hotel, Waikiki, Hawaii, c.1947. *Opposite Top*. The Playhouse Gallery, c. 1949. Netherland Plaza, c. 1949. *Bottom*. Liggetts Grill, c. 1947.

The Playhouse GALLERY

Luncheon ... at the Netherland Plaza Menu

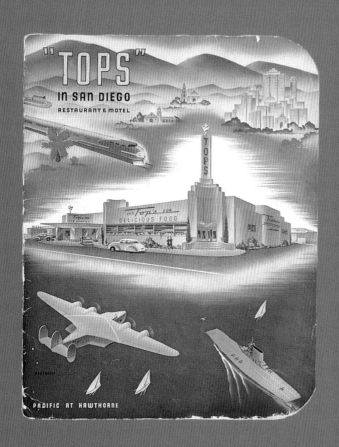

"TOPS"
IN SAN DIEGO
RESTAURANT & MOTEL

PACIFIC AT HAWTHORNE

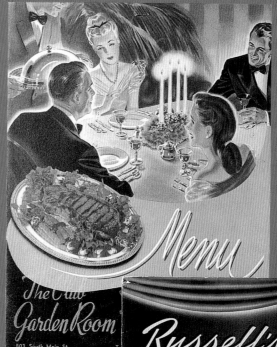

Menu

The Club
Garden Room
803 South Main St.

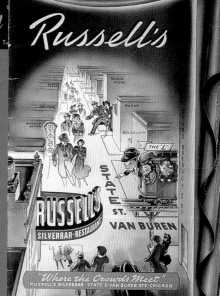

Russell's

RUSSELL'S
SILVERBAR · RESTAURANT

STATE ST.
VAN BUREN

"Where the Crowds Meet"
RUSSELL'S SILVERBAR · STATE & VAN BUREN STS · CHICAGO

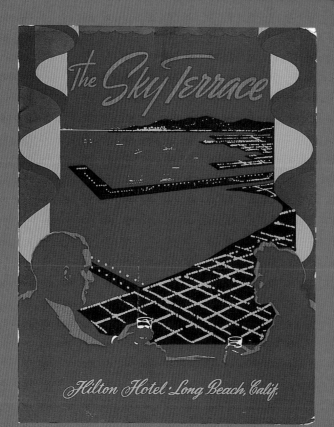

The Sky Terrace

Hilton Hotel · Long Beach, Calif.

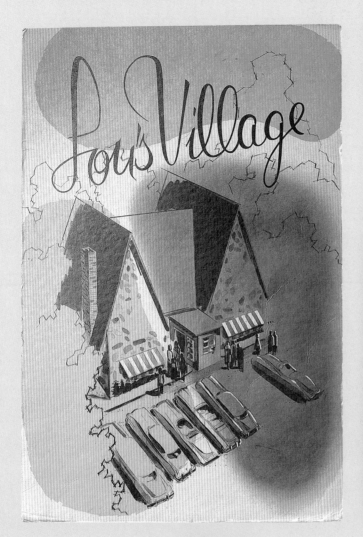

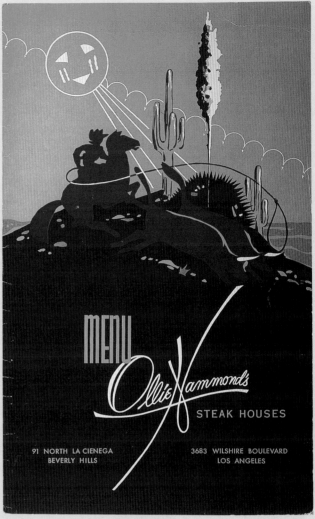

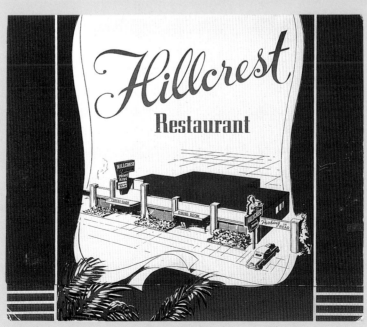

Informal '40s dining is expressed on these menus, which used airbrushing and silk screening to achieve their graphic brilliance. *Opposite.* Tops, San Diego, c. 1945. The Club Garden Room, Santa Ana, California, c. 1948. Russell's, Chicago, c. 1942. The Sky Terrace, Long Beach, California, c. 1949. *Above.* Oversized and elegant, this trio of menus perfectly matched postwar optimism in color and design. Lou's Village, San Jose, California, c. 1948. Ollie Hammond's, Beverly Hills, c. 1947. Hillcrest Restaurant, c. 1947.

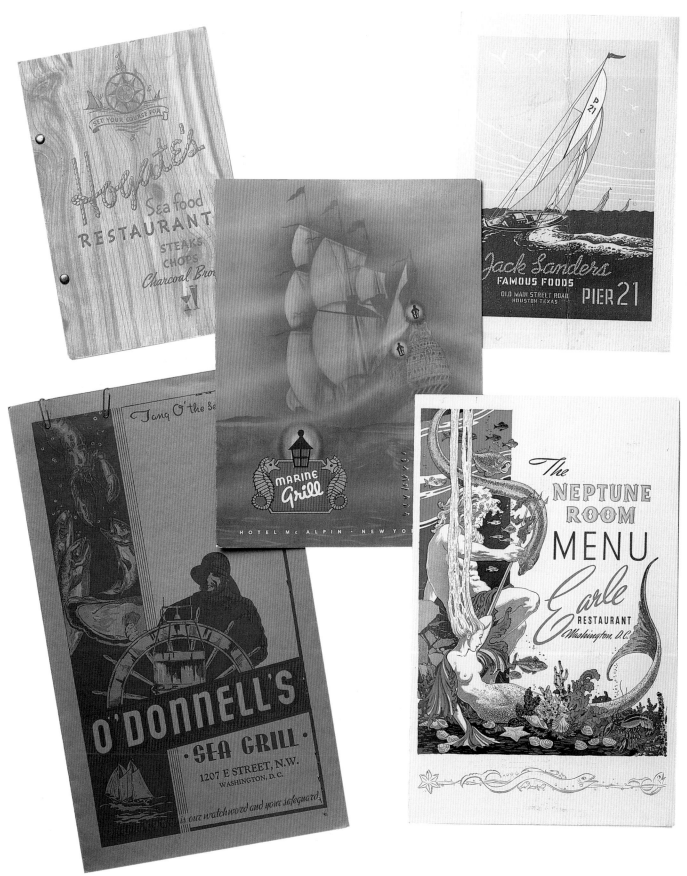

Seafood restaurants were a great source for colorful menu graphics. These 1940s covers demonstrate the variety and strong imagery of this category.

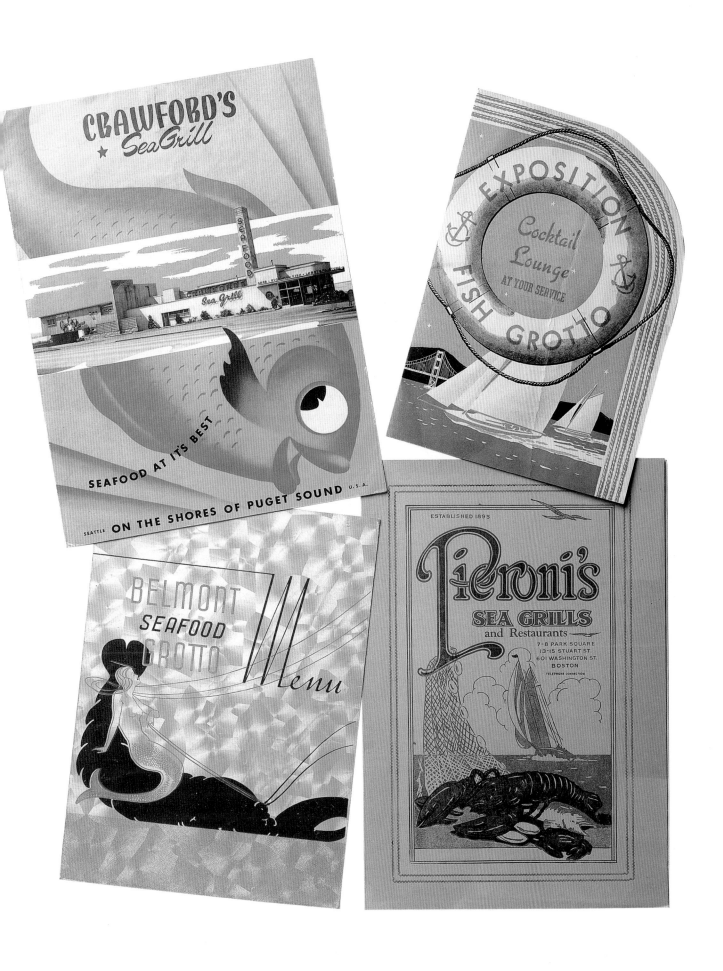

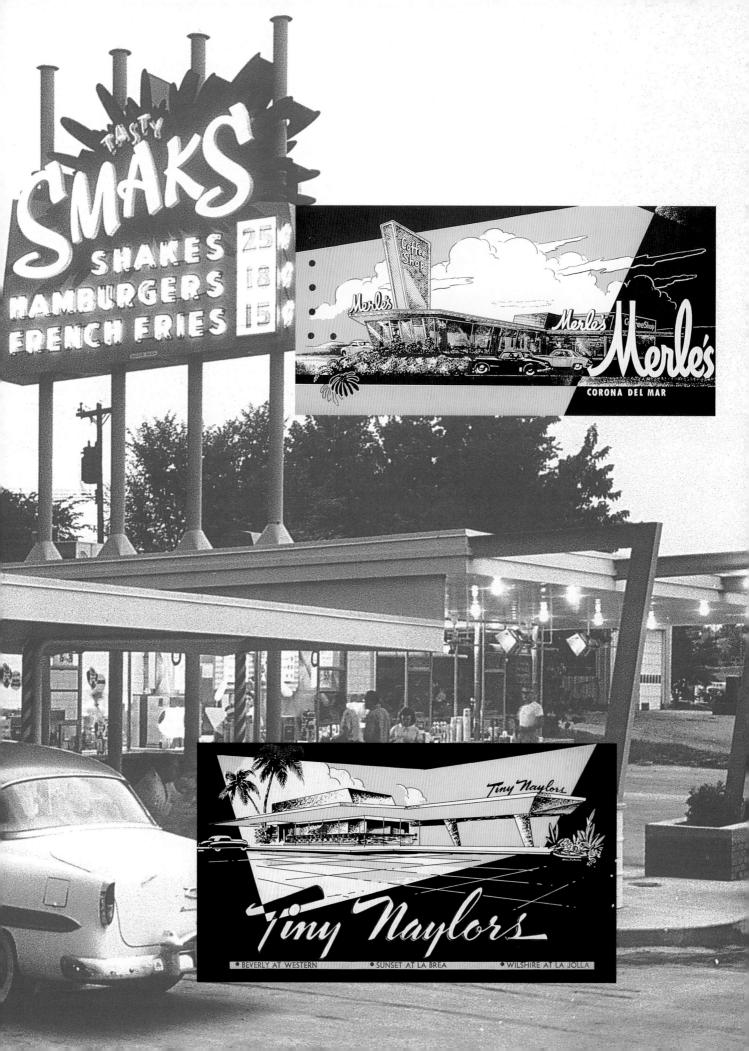

TASTY SMAKS

SHAKES 25¢
HAMBURGERS 18¢
FRENCH FRIES 15¢

Merle's
Coffee Shop

Merle's
Coffee Shop

Merle's
CORONA DEL MAR

Tiny Naylors

Tiny Naylors

• BEVERLY AT WESTERN • SUNSET AT LA BREA • WILSHIRE AT LA JOLLA

ATOMS, JETS, AND DRIVE-INS
Menus of the 1950s

Several dining trends that began in the postwar period of the forties continued to the fifties. Pizza parlors, pancake houses, ice cream stands, and restaurants that featured specialized foods made an impressive dent in mainstream dining. But the rise of self-service fast-food outlets forever changed America's eating habits. The demographics were perfect. Suburban sprawl was decentralizing city centers, and a casual, middle-class lifestyle was the model most people desired. Families still had their primary meals at home, but when they did go out it was good-bye to fancy eating joints, except for special occasions. Self-service outlets were aimed at families who had small budgets and limited time to eat. The convenience of taking home prepared food or eating it in your car was the ultimate in casual dining. This of course eliminated the need for a printed menu.

Nonetheless the creative menu cover continued as a strong marketing tool in coffee shops, nightclubs, department store restaurants, lounges, and bars. The emphasis on casual

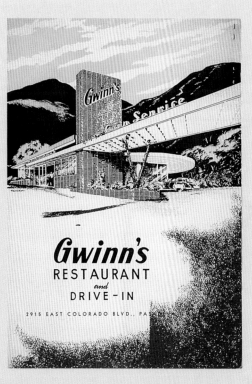

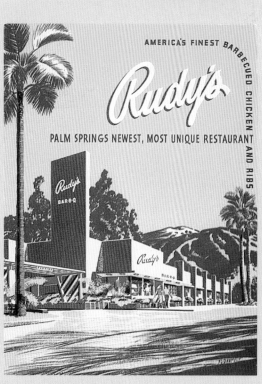

Fast food and drive-ins were icons of 1950s cuisine. *Opposite.* The menus from Tiny Naylor's, c. 1956, and Merle's, c. 1955, reflect that era's jet-age elements. *Above.* Contemporary colors and cool styling give menus from Gwinn's, c. 1954 and Rudy's, Palm Springs, c. 1953, a sophisticated '50s look.

dining was soon evident in the graphics on many of the menus from this period. The relaxed atmosphere of the era combined with atomic age sensibilities created a climate for graphic experimentation. Design theory introduced in the thirties continued to be integrated in commercial art throughout the forties and fifties. Taking their cue from architecture and fine-art sources, commercial artists appropriated and implemented many of these symbolic devices. Quirky and whimsical abstractions were common. Organic shapes and surrealistic images added drama to restaurants whose patrons were savvy enough to appreciate the latest in visual sophistication. Architects such as Morris Lapidus and his baroque fantasy hotels of Miami, Wayne McCallister, who created resorts and restaurants in Los Angeles and Las Vegas, Armet and Davis with their "Googie" style coffee shops, and interior designer Dorothy Draper, who created high style in Chicago and the East gave graphic designers plenty of fuel for two-dimensional artistic expression. Cueing menu covers to a restaurant's architectural and interior details completed a design system by coordinating all the facets of a restaurant.

The atomic age, a by-product of postwar optimism, was another theme exploited in the '50s. Space travel, jet aircraft, and speed fascinated Americans. Popularly priced air travel, introduced at decade's end, made the future even more tangible. Attempting to associate with this phenonomen, commercial artists produced imagery that spoke of these developments. Typefaces affected spikes and angles. Letterforms tilted and space motifs such as sputniks, starbursts, and biomorphic boomerangs were liberally scattered on menu covers. Coffee shops of this period, particularly those in Southern California, were prime showcases of these influences.

Comic figures and scenes also continued to be popular menu treatments. Led by studios such as United Productions of America (UPA), cartoons in

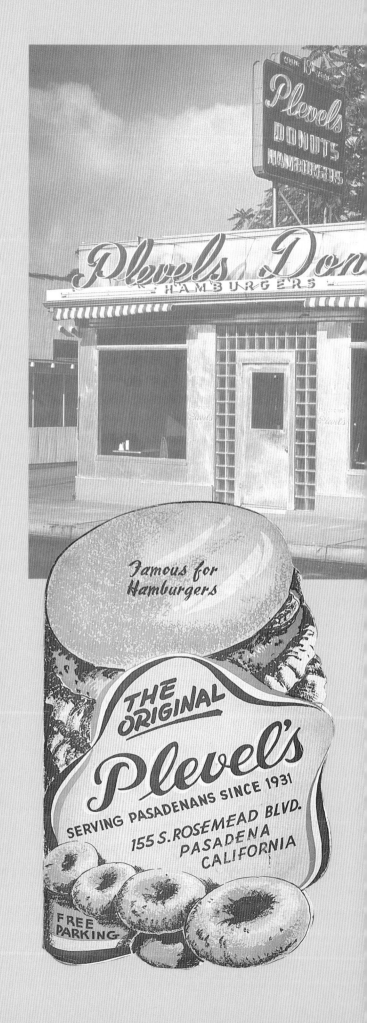

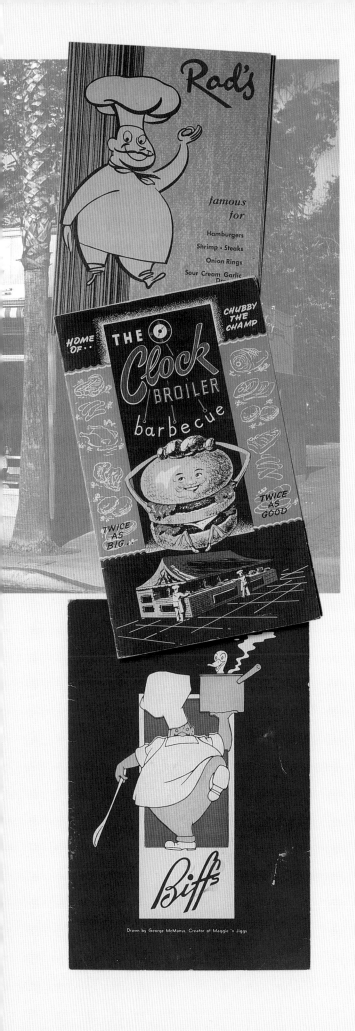

the fifties took on a decidedly abstract look, minimizing the lush realism Disney and Fleischer studios had pioneered. It was bare-bones abstraction, and it seemed to fit a faster-paced America. Following these developments in the animation industry, designers grafted this style of drawing and lettering onto menu covers, suggesting a restaurant as a hip, quick place to grab a bite. *Simplify* and *abstract* were buzzwords of their day.

Illustrative solutions dominated menu covers, but photographic treatments for menus were still in use. One exception to the mostly banal uses of photography was a series of menus for the Awahnee Hotel in Yosemite National Park. The simple yet exquisite black-and-white photos by Ansel Adams conveyed the seasonal beauty of the preserve. Menu design in the '50s continued to use a wide range of artistic references from high art to mass-produced art. Swiss design, which emphasized minimalism, clarity, and order, internationalism, the New York School, and other formal design dictums trickled down to the popular arts and were used increasingly for high-end restaurant menus where these types of graphics could be appreciated.

Small burger joints and food stands could be found on almost any American street corner in the early '50s and whimsical characters were a popular motif for many of their covers. *Opposite.* Plevel's, Pasadena, California, c. 1952. *Left.* Rod's, c. 1950. The Clock Broiler, c. 1954. Biff's, c. 1956.

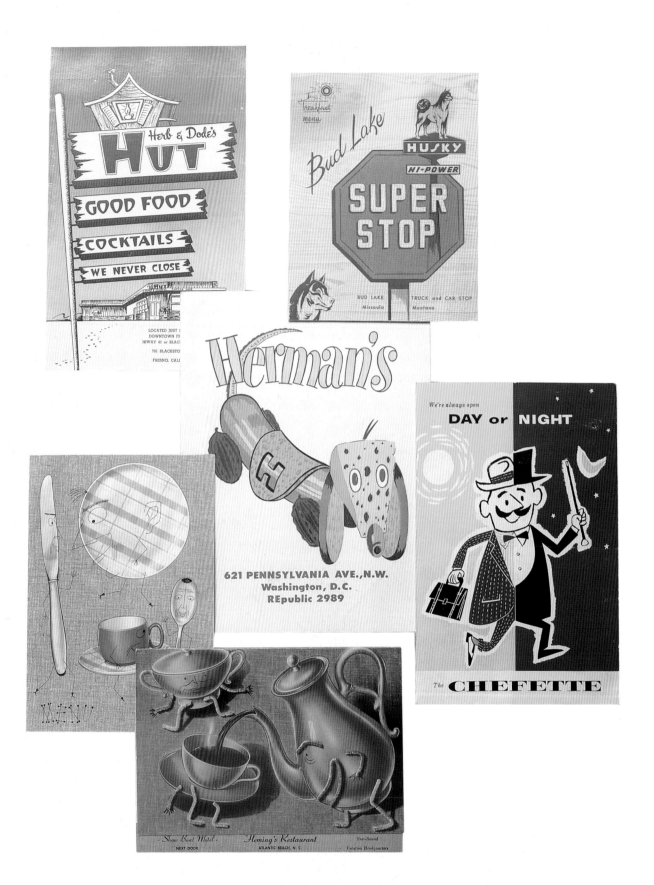

Lighthearted and graphically bold, these menus typify '50s sensibilities. *Clockwise.* The Hut, Fresno, California, c. 1954. Bud Lake Super Stop, Missoula, Montana, c. 1955. The Chefette, Dallas, Texas, c. 1959. Vanderbilt Hotel, c. 1956. Fleming's Restaurant, Atlantic Beach, North Carolina, c. 1953, Herman's, Washington D.C., c. 1955.

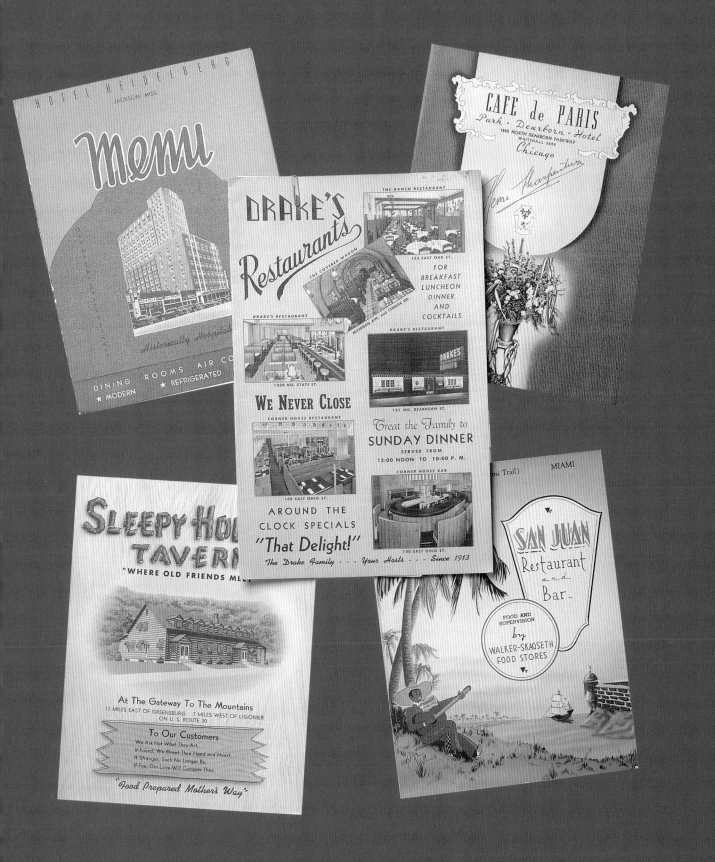

Chicago postcard printer Curt Teich also specialized in menu printing and design. These covers are typical of the saturated color and linen texture the company produced. *Clockwise.* Cafe de Paris, Chicago, c. 1950. San Juan Restaurant, Miami, c. 1950. Sleepy Hollow Tavern, c. 1950. Hotel Heidelberg, Jackson, Mississippi, c. 1950. Drake's Restaurant, Chicago, c. 1950.

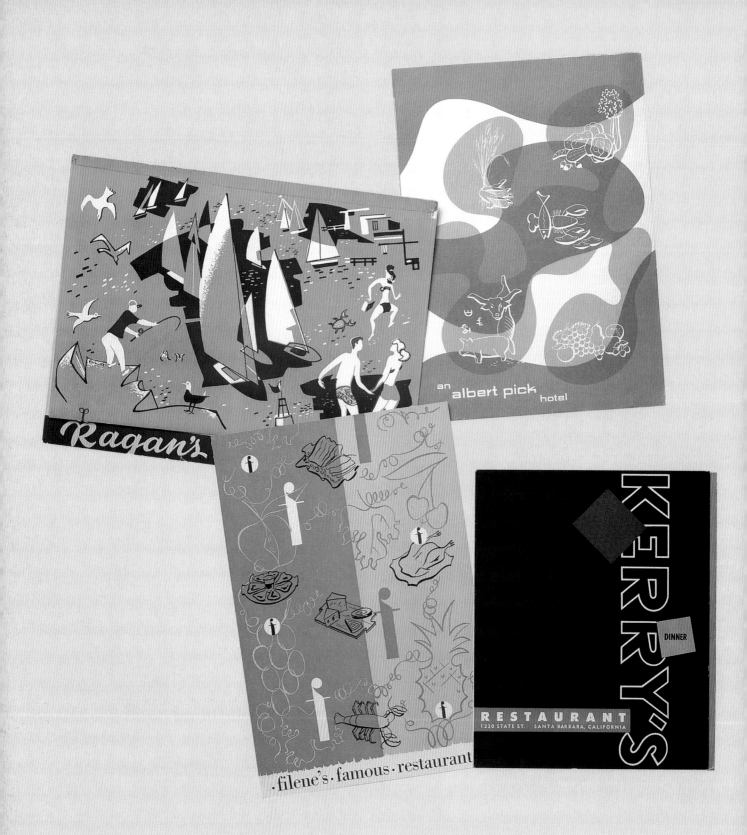

The height of '50s cool is expressed on the covers of these abstracted menu designs. Abandoning figurative elements, hip restaurants gravitated to this new look to keep current in the competitive food industry. *Above.* Albert Pick Hotel, c. 1950. Ragan's, Coron Del Mar, California, c. 1958. Filene's, Massachusetts, c. 1951. Kerry's, Santa Barbara, c. 1956. *Opposite.* Pan Lad, Los Angeles, c. 1952. Huddle, Los Angeles, c. 1957. Congo Room, Sahara Hotel, Las Vegas, c. 1958. Tapa Room, Honolulu, c. 1959. Brennan's, c. 1952. Wil Wright's, Los Angeles, c. 1958.

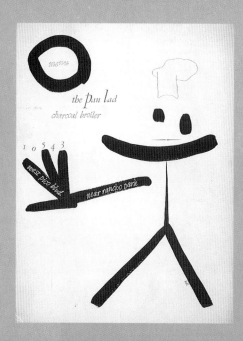

the pan lad
charcoal broiler

1 0 5 4 3

west pico blvd.
near rancho park

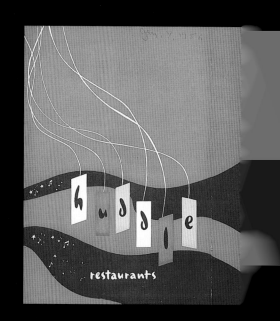

hussie

restaurants

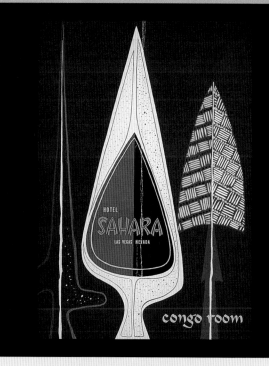

HOTEL
SAHARA
LAS VEGAS NEVADA

congo room

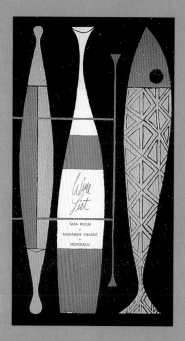

Wine
List

TAPA ROOM
•
HAWAIIAN VILLAGE
•
HONOLULU

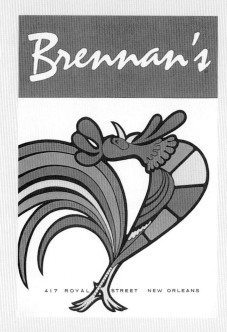

Brennan's

417 ROYAL STREET NEW ORLEANS

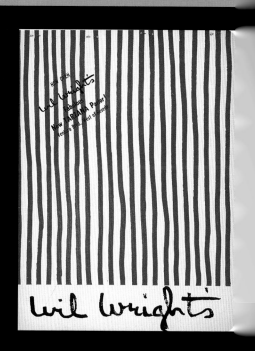

wil wright's

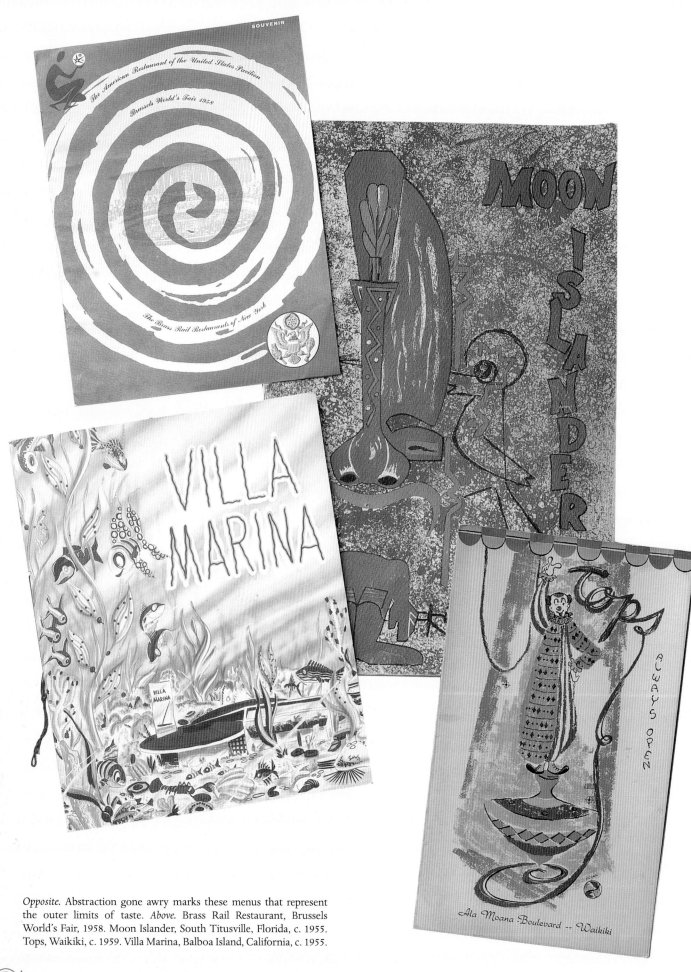

Opposite. Abstraction gone awry marks these menus that represent the outer limits of taste. *Above.* Brass Rail Restaurant, Brussels World's Fair, 1958. Moon Islander, South Titusville, Florida, c. 1955. Tops, Waikiki, c. 1959. Villa Marina, Balboa Island, California, c. 1955.

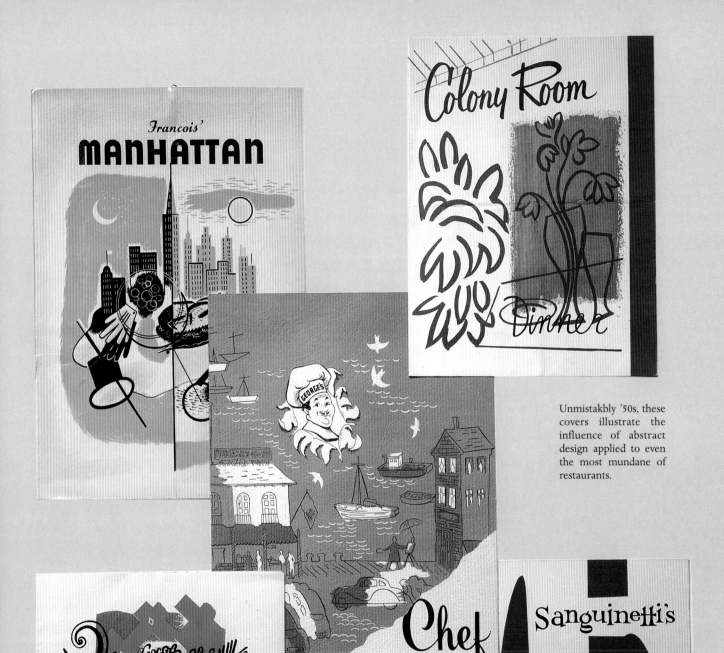

Unmistakbly '50s, these covers illustrate the influence of abstract design applied to even the most mundane of restaurants.

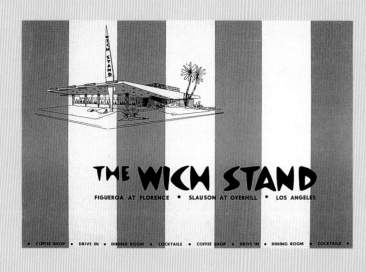

THE WICH STAND

FIGUEROA AT FLORENCE • SLAUSON AT OVERHILL • LOS ANGELES

• COFFEE SHOP • DRIVE IN • DINING ROOM • COCKTAILS • COFFEE SHOP • DRIVE IN • DINING ROOM • COCKTAILS •

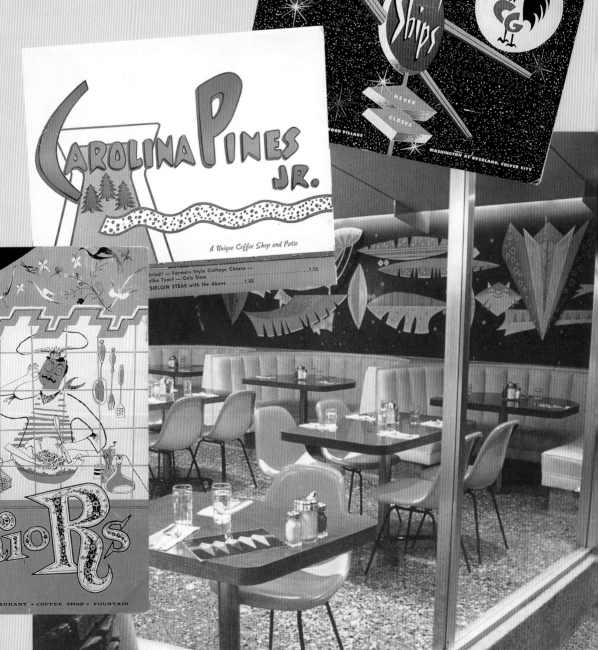

La Cometa

Ships COFFEE SHOP

NEVER CLOSES

WESTWOOD VILLAGE

WASHINGTON AT OVERLAND, CULVER CITY

Carolina Pines JR.

A Unique Coffee Shop and Patio

Grind) — Farmers Style Cottage Cheese —..........1.10
elba Toast — Cole Slaw
SIRLOIN STEAK with the Above........1.55

JunioRs

the place where everyone meets

RESTAURANT • COFFEE SHOP • FOUNTAIN

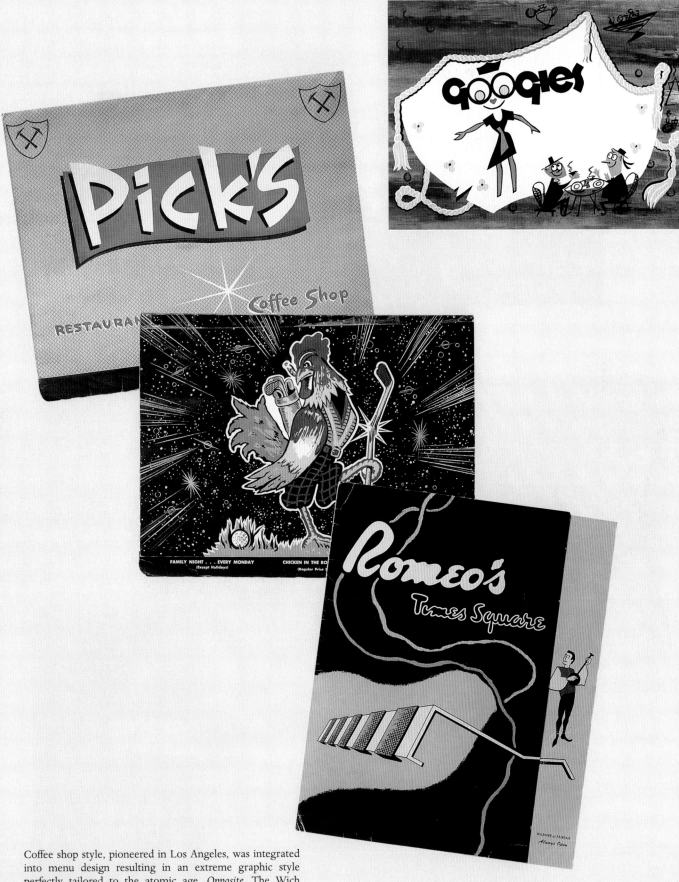

Coffee shop style, pioneered in Los Angeles, was integrated into menu design resulting in an extreme graphic style perfectly tailored to the atomic age. *Opposite.* The Wich Stand, c. 1959. Ships, c. 1958. Carolina Pines Jr., c. 1958. Juniors, c. 1956. *Above.* Googies, c. 1958. Pick's, c. 1959. Henry's, c. 1959. Romeo's Times Square, c. 1956.

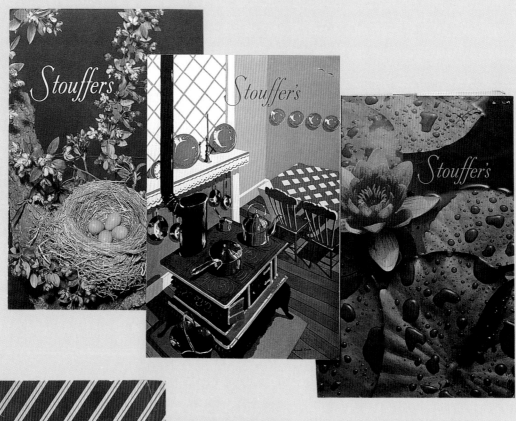

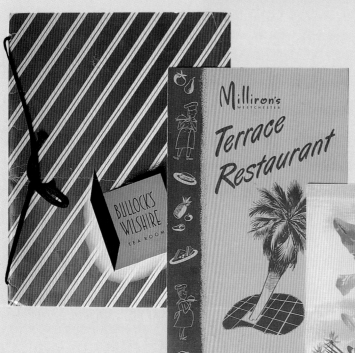

Above. Stouffer's restaurants were found throughout the Northeast and Midwest and produced a series of tasteful menu covers. *Below.* Department store tea rooms and restaurants were popular suburban dining venues that produced pleasing menu art throughout the '50s. Bullock's Wilshire Tea Room, c. 1950. Milliron's, c. 1952. Marshall Field, c. 1951. Bullock's Coral Room, c. 1959.

Opposite. Abandoning color for an understated and classic image, black-and-white photos were a refined alternative to the more colorful graphics of standard menu design. *Top.* Ansel Adams photos for the Awanhee Hotel, Yosemite National Park, c. 1955. *Bottom.* Tick Tock, Hollywood, c. 1954. Spenger's, Berkeley, California, c. 1952. Carl's, Los Angeles, c. 1955.

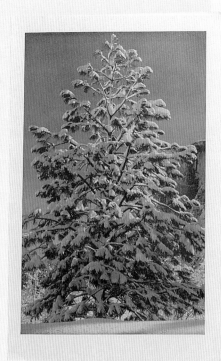 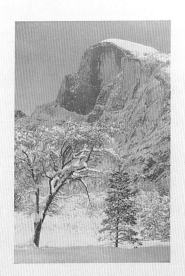 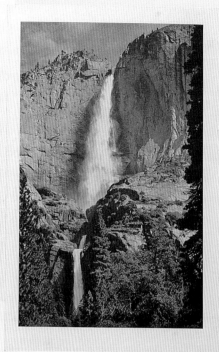

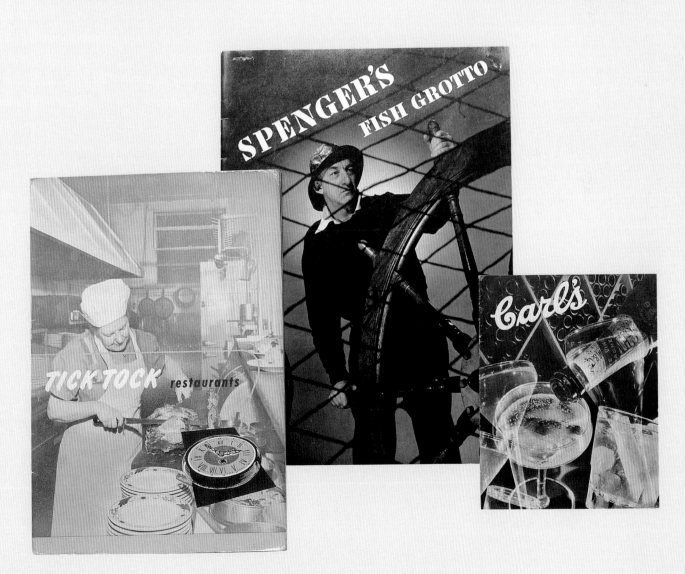

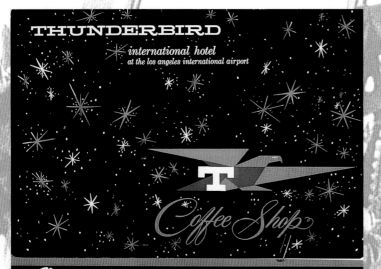

THUNDERBIRD

international hotel
at the los angeles international airport

Coffee Shop

Around the Clock 24 HOURS

WE PREPARE *Kentucky Fried Chicken* FOR ANY SIZE GROUP UP TO 5,000!

PANCAKES

Sambo's
RESTAURANTS

CHICKEN

STEAKS

SANDWICHES

SALADS

BREAKFAST • LUNCH • DINNER

Your Souvenir Menu

FAST FOOD
AND FADS
Menus of the 1960s

Throughout the sixties casual dining continued to be popular. Fast-food outlets had eliminated the printed menu, which left coffee shops, chains, and small regional restaurants to produce interesting menu art. Distinctive menu art also appeared in fine dining restaurants, ships, nightclubs, and Las Vegas resorts. Designers found inspiration in the rediscovery of vintage designs and clip art from the Victorian period. These designs graced many covers from the first half of the decade and represented a shift toward representational art and away from the abstractions of the previous fifteen years.

The tail end of the fifties and the first part of the sixties saw another revival of sorts when a Polynesian craze hit the restaurant industry. No doubt Hawaii's inclusion as a state prompted this renewed interest in the exotic allure of tropical dining. Trader Vic's and Don the Beachcomber had already established outposts in cities all over the United States, but soon even the smallest hamlet was offering luaus and tiki lounges to a public with an endless

Casual dining in the '60s set the tone for a further reduction of complicated menu design with chain restaurants eroding the individuality of cover art. *Left.* Thunderbird Coffee Shop, Los Angeles, c. 1961. Sambo's, c. 1965. Kentucky Fried Chicken, c. 1964. *Top.* Original Pancake House, c. 1965. International House of Pancakes, c. 1963.

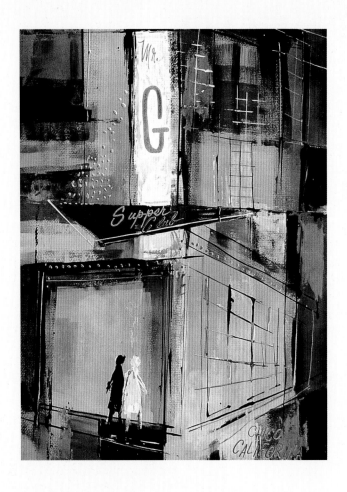

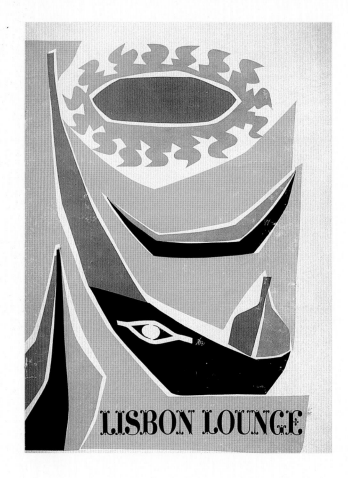

appetite for things new and different.

Chain restaurants continued to play an important part in where Americans chose to dine. In addition to the established Howard Johnson's, other restaurants built multiple units. While making eating a comfortable and familiar experience, this duplicity made menu covers repetitive with corporate consistency.

Air travel, which until midcentury had been reserved for patrons able to afford the expensive tariff, became more common with the introduction of commercial jets in the late fifties. Food service aboard early airliners had been distinguished. Menu art from these in-flight meals suggested a certain elegance to dining in the air. Later airline menus became more simplified as passenger counts increased, and finally the printed menu was eliminated in coach as meals became more bland. Certain airlines continued the tradition of a printed menu, but this practice was usually reserved for first-class passengers or offered on international carriers.

One last graphic burst at the end of the sixties was the health food movement, which coincided with the rise of the counterculture. Everything associated with this phenomenon was called "psychedelic," and several restaurants in the San Francisco Bay Area made use of this theme on their menu covers.

Overall, menu graphics from the sixties tended to be generic, lacking the exuberance and printing complexities of previous decades. No single design movement influenced or dominated sixties menu cover art. The tendency was to fit in rather than to make a visual statement. This situation continued into the seventies and early eighties, when a dining renaissance would again inspire menus of distinctive design quality.

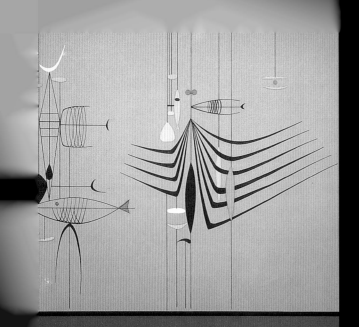

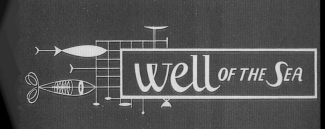

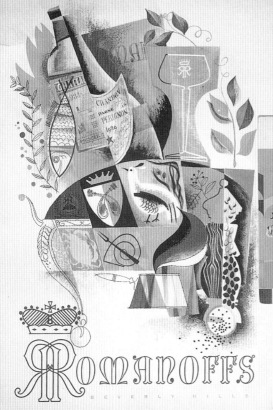

Smart dining in the '60s was characterized by oversized men
continuation of simplified '50s abstraction. *Opposite.* Mr. G
California, c. 1960. Lisbon Lounge, c. 1961. *Above.* Well of
Chicago, 1964. Potomac Room, c. 1966. Romanoff's, Beverl
1960. Terrace Room, Las Vegas, c. 1960.

By the mid-'60s menu covers used a number of new graphic devices. Victorian clip art, historical and contemporary typography, and simplified line drawings were incorporated with satisfying results.

Opposite. Menus from Le Pavillon and the Forum of the Twelve Caesars represented the apex of fine dining. *Bottom.* Two specially commissioned menus for charity events at the Waldorf Astoria, c. 1960.

Le Pavillon
MENU

Déjeuner

Jambon de Bayonne 2.50 Melon 1.50 Grapefruit 1.10
Caviar Malossol Foie Gras Truffé 6.00
Saumon Fumé 3.50 Cherrystones 1.50 Anguille Fumée 2.75
Cocktails: Lobster 6.00 Shrimps 3.50 Crab Meat 4.50

Oeufs

Cocotte Princesse 3.00 Plat Meyerbeer 3.25
Gril Américaine 3.00 Froids à la Gelée 1.75
Brouillés aux Champignons 3.25 Mollet aux Epinards 3.25

Poissons

Homard Thermidor 7.50 Crab Meat Nantua 5.00
 Grenouilles aux Fines Herbes 5.00
...on-Bart 4.75 Moules du Pêcheur 3.75 Truite de Rivière Arlésienne 4.50
Sole Anglaise Moules 3.75

Plats du Jour

...ÉE 6.75 FRICASSEE DE VOLAILLE AU CHAMPAGNE 6.50
...50 Foies de Volaille Algérienne 4.25 Rognons Sautés au Chablis 4.75
 Jambon Madère aux Epinards 4.25 Emincé de Volaille St. Germain 5.00
 Sauté de Filet de Boeuf Bercy 5.50 Ris de Veau Meunière 5.00
...and (Pour 2) 10.00 P.P. Volaille (selon grosseur) Ris de Veau 6.00

Grillades

...aise (Pour 2) 10.00 P.P. Côte d'Agneau aux Haricots-Verts 7.00
...75 Poulet de Grain Diablé. (Pour 2) 6.50 p.p. Pigeon en Crapaudine 6.00
 Entrecôte Minute Pavillon 7.75

Plats Froids

Poularde à la Gelée 5.00 Langue Ciurée 3.25 Boeuf Mode à la Gelée 4.50
Terrine de Canard 4.50 Jambon d'York 3.50 Terrine de Volaille 4.50

Légumes

Haricots Verts Ménagère 2.00 Courgette Sautée 2.00 Petits Pois Paysanne 2.00 Laitue au Jus 2.00
Aubergine Provençale 2.00 Céleris au Beurre 2.00 Artichaut Vinaigrette 2.00
Choux-Fleurs au Gratin 2.25 Epinards au Velouté 2.00 Champignons au Porto 2.50

Entremets

Patisserie Pavillon 2.50 Crêpes Pavillon 3.00
Poire Hélène 2.75 Soufflés Tous Parfums 3.50 Désir de Roi 2.25
Coupe aux Marrons 2.25 Pêche Melba 2.50 Macédoine de Fruits aux Liqueurs 2.50
 Glaces: Vanille 1.00 Chocolat 1.00 Framboise 1.00 Moka 1.00 Citron 1.00 Fraise 1.00
Café .75 Demi-Tasse .65 Bread and Butter 1.00

THE FORVM
OF THE TWELVE CAESARS

"NIGHT AT MAXIM...

april in paris

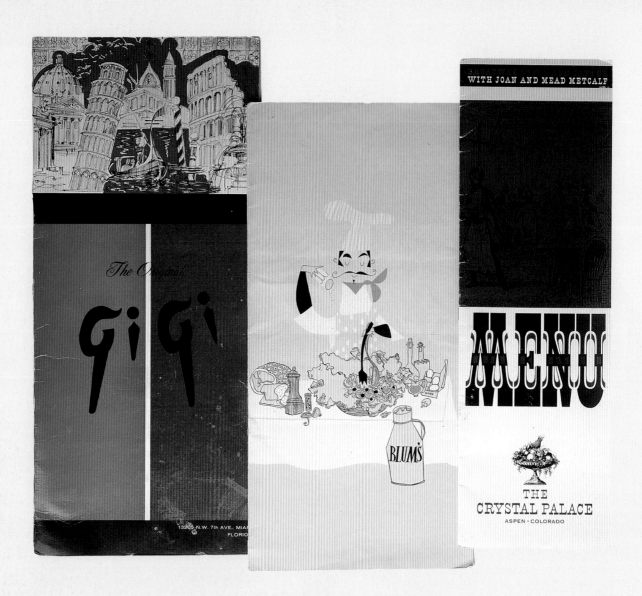

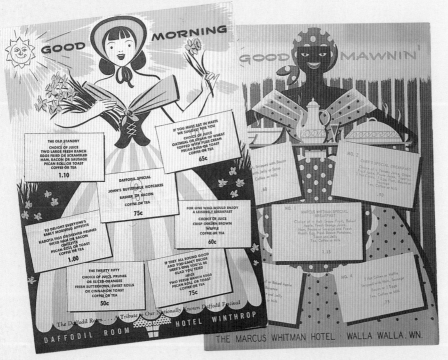

Tall, elongated menus were a popular '60s style for restaurants serving lighter fare. Gigi, Miami, c. 1966. Blum's, San Francisco, c. 1965. Crystal Palace, Aspen, c. 1964. *Bottom.* A Southern belle and black servant, both identically rendered, provide a contrast in racial stereotyping still prevalent in the mid-'60s.

Opposite. The psychedelic movement at the end of the 1960s produced a few rare menus that infused the hippie spirit. Two fine examples are the Trident, Sausalito, California, c. 1968 and the Whale, Mill Valley, California, c. 1971.

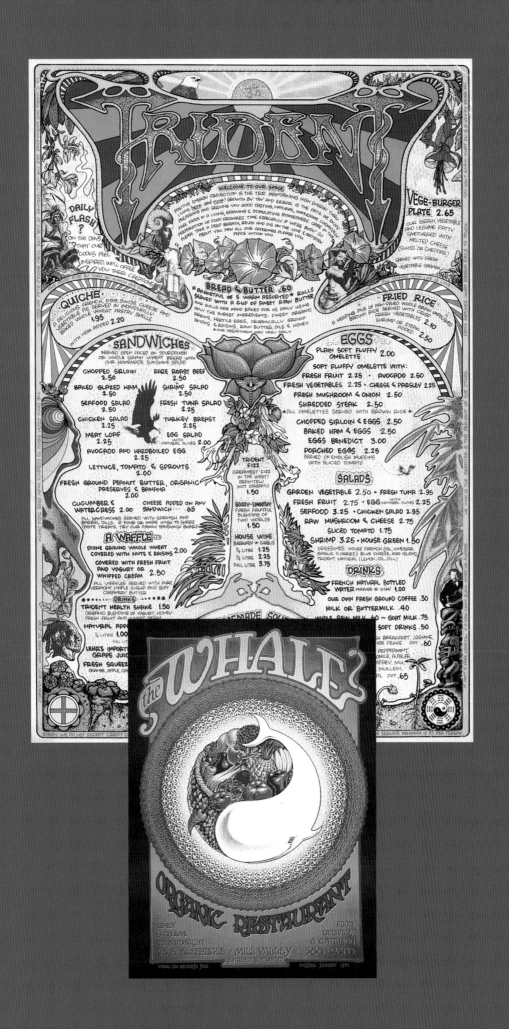

MENU MAGIC
The Specialty Menu

To sustain customer interest, restaurateurs have continually sought new ways to embellish the dining experience. The menu, that introduced a customer to a restaurant's bill of fare, has always been important for catching people's attention and introducing them to new dining ideas. Graphics played an important part in this process, but the need to add additional embellishments to a menu developed early on.

Inspiration for unusual menus could be found where meals became special occasions, commemorating an event or celebrating a personality. These opportunities to try something different were possible because a limited number of menus were produced and cost was not always a factor. Many menus from the first part of the twentieth century exemplified this trend, having unusual shapes, die-cuts, and embossing. Gold or silver ink, ribbons, braid, and even feathers were employed to create a lasting souvenir of a memorable fête.

The most common variation to the standard rectilinear menu was the

Opposite. Happy clams and crabs delighted diners with their unusual shapes for these various seafood restaurants. *Top.* A menu shaped like a wine jug from the Veneto Restaurant in San Francisco, c. 1955. *Bottom.* Topsy's Ballroom, chicken on a log, South Gate, California, c. 1931.

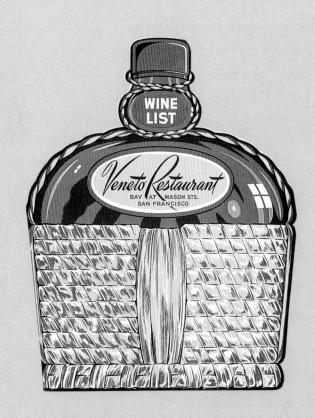

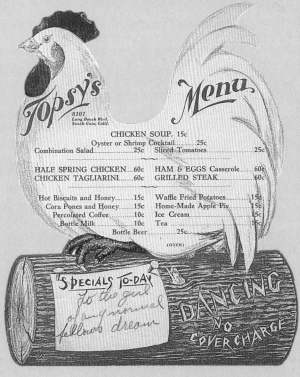

die-cut. An unusual shape was a relatively inexpensive attention-getter and used frequently. Menus became clams, sailboats, or covered wagons. In the case of children's menus, die-cutting produced whimsical animals, toys, or even masks aimed at appeasing and amusing dining youngsters. The restaurant industry encouraged the creation of novel and interesting menus as a way to motivate diners to sample more of a restaurant's items and to encourage customers to return. Printers were a factor in the production of novelty menus, suggesting new materials and different ways to set a restaurant apart. Printing had progressed to such a degree by the 1920s that almost any material could be utilized in the printing process. Menus were printed on plastic and napkins, on placemats and metal skillets, and even delivered on wine bottles. The menu for Rancho Las Vegas, silk screened on a plank of elliptical wood, was a show-stopper in a town where the unusual was expected. Tent cards preset at a table were also popular. These could be simple advertisements for featured items and new products or elaborate three-dimensional die-cuts. The cost of such deviations from a standard format was often prohibitive. As a substitute, most restaurants simply relied on creative graphics to supply the necessary identity.

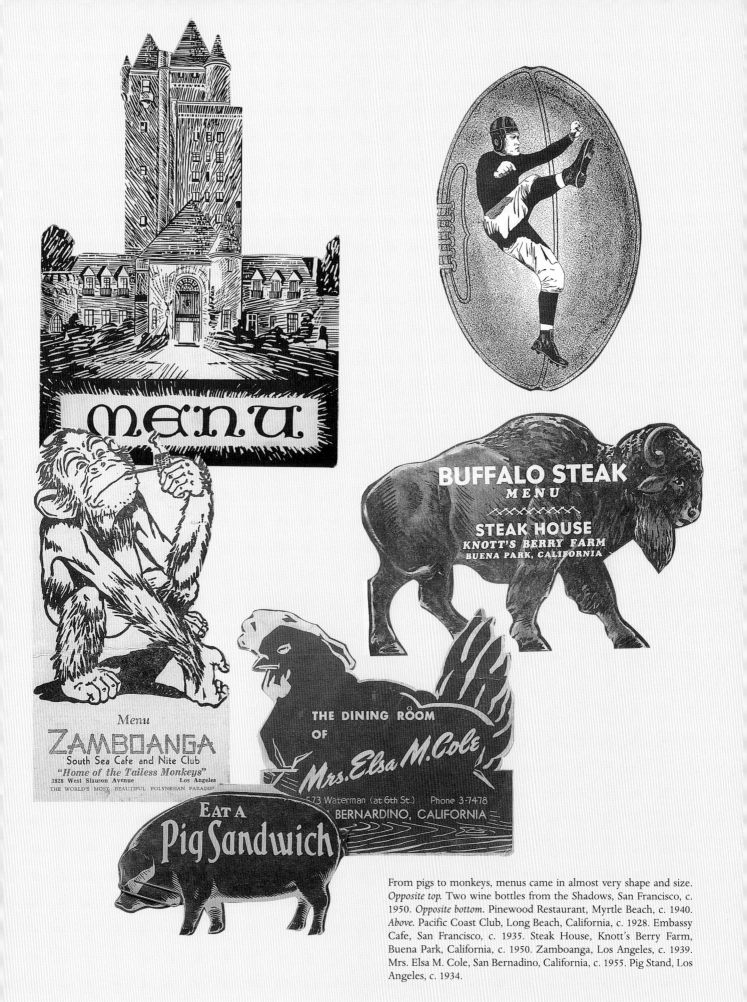

From pigs to monkeys, menus came in almost very shape and size. *Opposite top.* Two wine bottles from the Shadows, San Francisco, c. 1950. *Opposite bottom.* Pinewood Restaurant, Myrtle Beach, c. 1940. *Above.* Pacific Coast Club, Long Beach, California, c. 1928. Embassy Cafe, San Francisco, c. 1935. Steak House, Knott's Berry Farm, Buena Park, California, c. 1950. Zamboanga, Los Angeles, c. 1939. Mrs. Elsa M. Cole, San Bernadino, California, c. 1955. Pig Stand, Los Angeles, c. 1934.

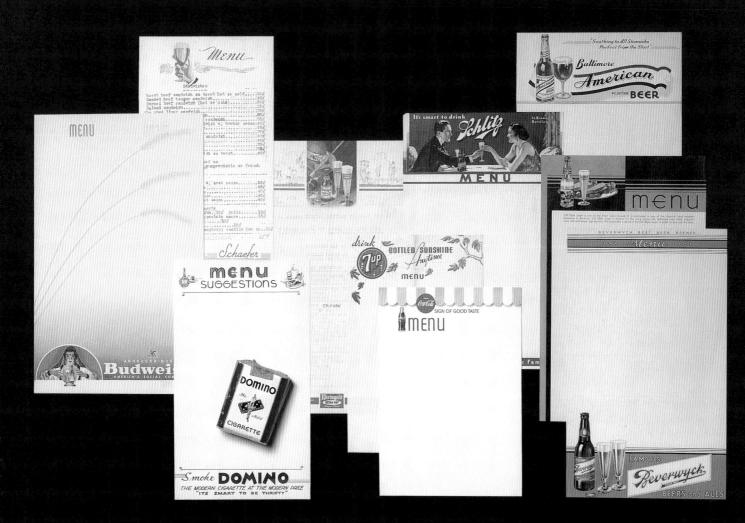

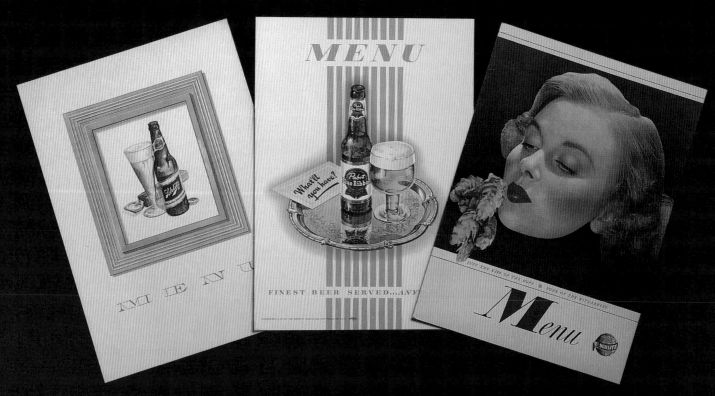

Stock menus provided to restaurants by vendors advertised products in exchange for the expensive look of full-color covers.

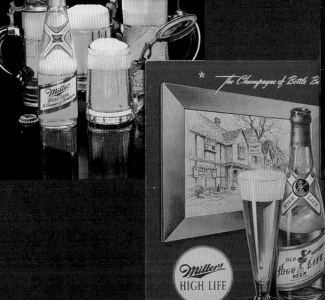

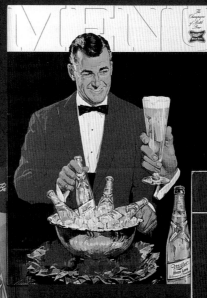

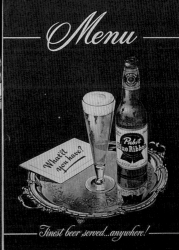

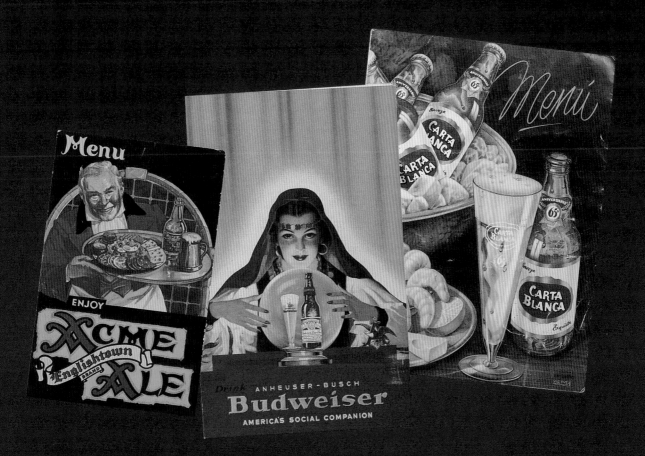

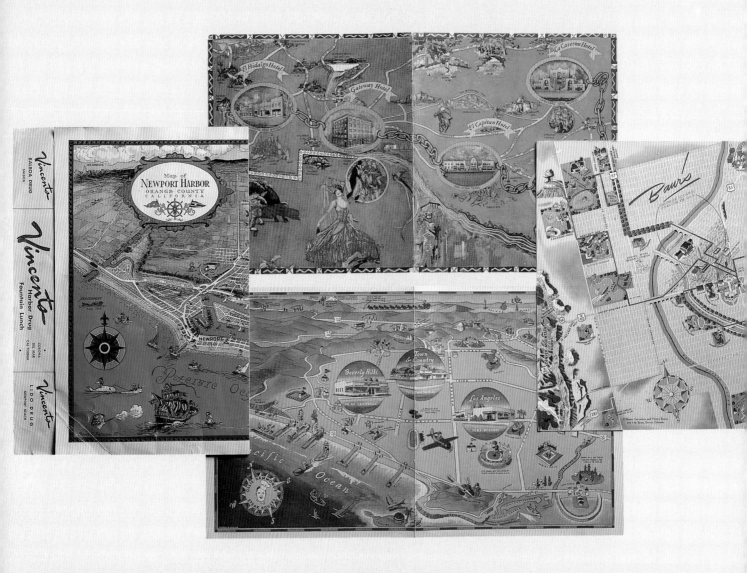

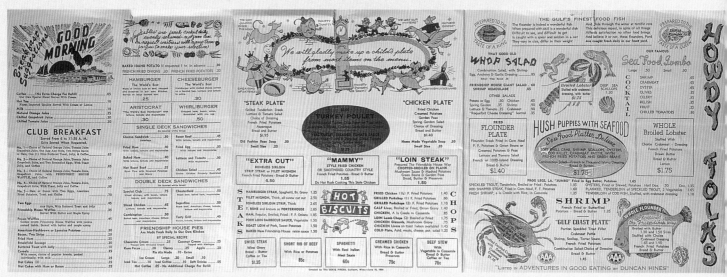

Decorative maps showing a restaurant's location and local landmarks were a popular menu tradition. Menu interiors could be as informative and exciting as the covers. Two great examples illustrating the sales power of creative menu design: *Above.* The Friendship House, Mississippi City, Mississippi, c. 1954. *Opposite.* Pep Soda Fountain, Santa Cruz, California, c. 1950.

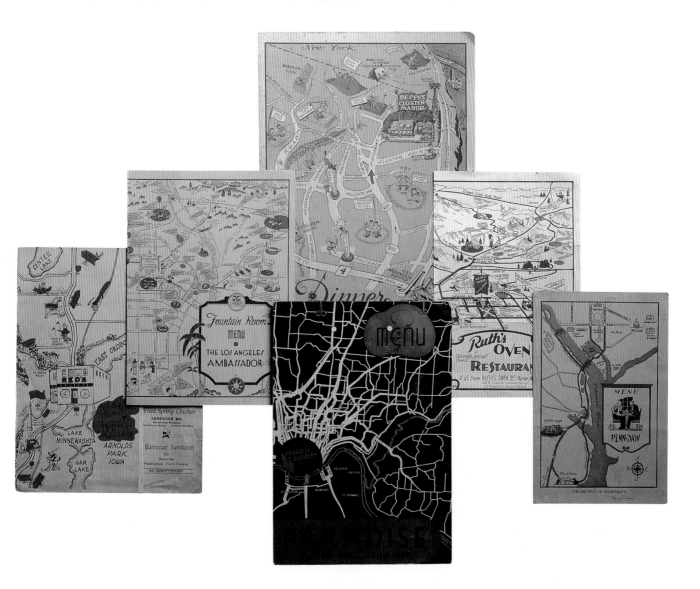

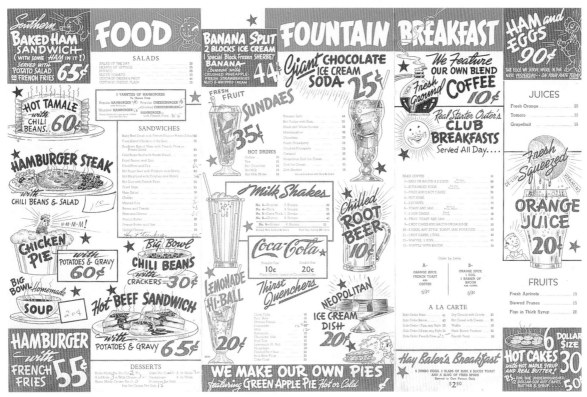

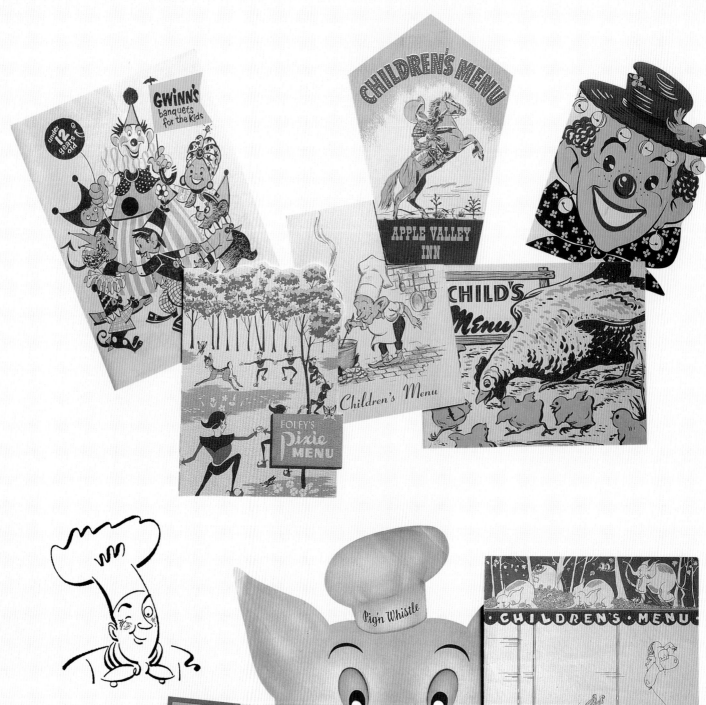

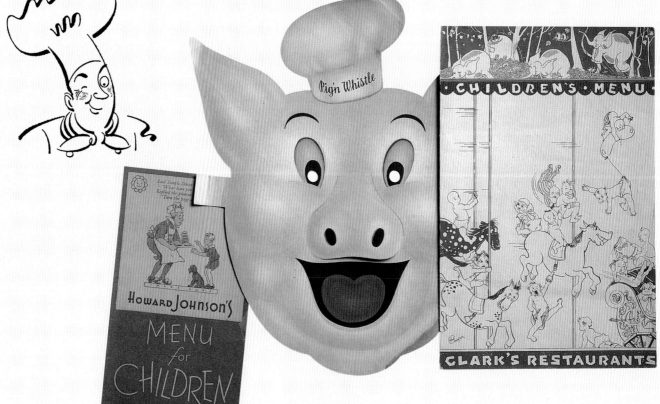

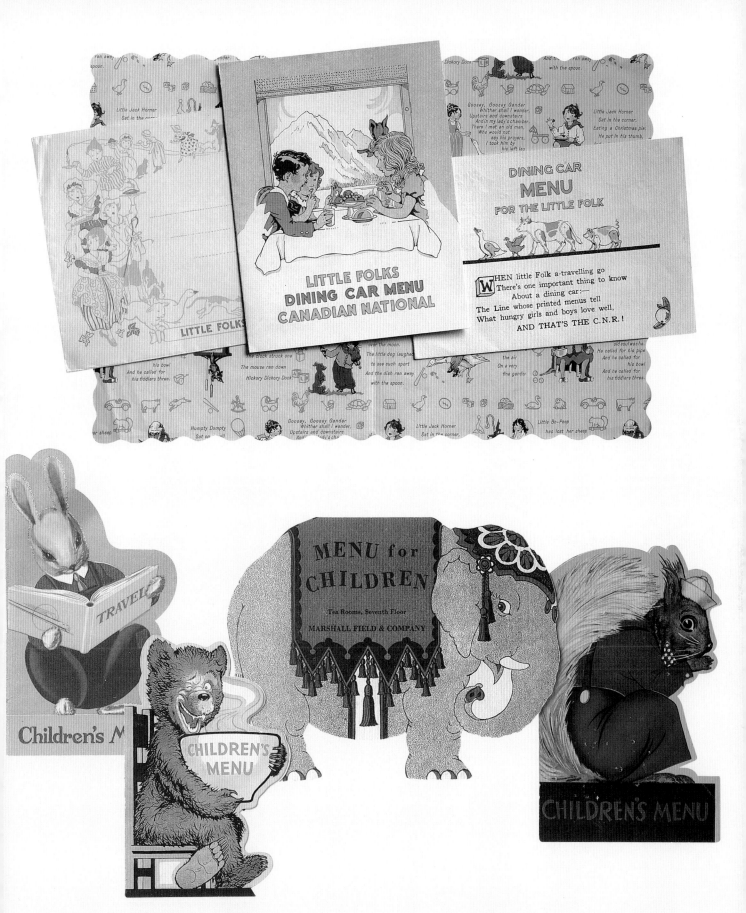

A delight to the eye, children's menus were whimsical miniature versions of adult menus prized by collectors. *Opposite top.* Gwinn's, 1966. Foley's Pixie, c. 1952. Betty's Restaurant, Miami, c. 1955. This menu for the Apple Valley Inn, c. 1953, featured a Lone Ranger Dinner costing "12 dimes and eleven nickels." Henry's, c. 1949. Clown, Northern Hotel, Billings, Montana, c. 1949. *Opposite bottom.* Howard Johnson's, c. 1940. Pig 'n Whistle, c. 1943. Clark's Restaurant, c. 1938. *Above top.* Dining car menu, Canadian National Railways, c. 1925. *Above bottom.* Streamliner, City of Portland, 1947. Yosemite National Park, c. 1935. Marshall Field Department Store, c. 1943. Grand Canyon National Park, c. 1936.

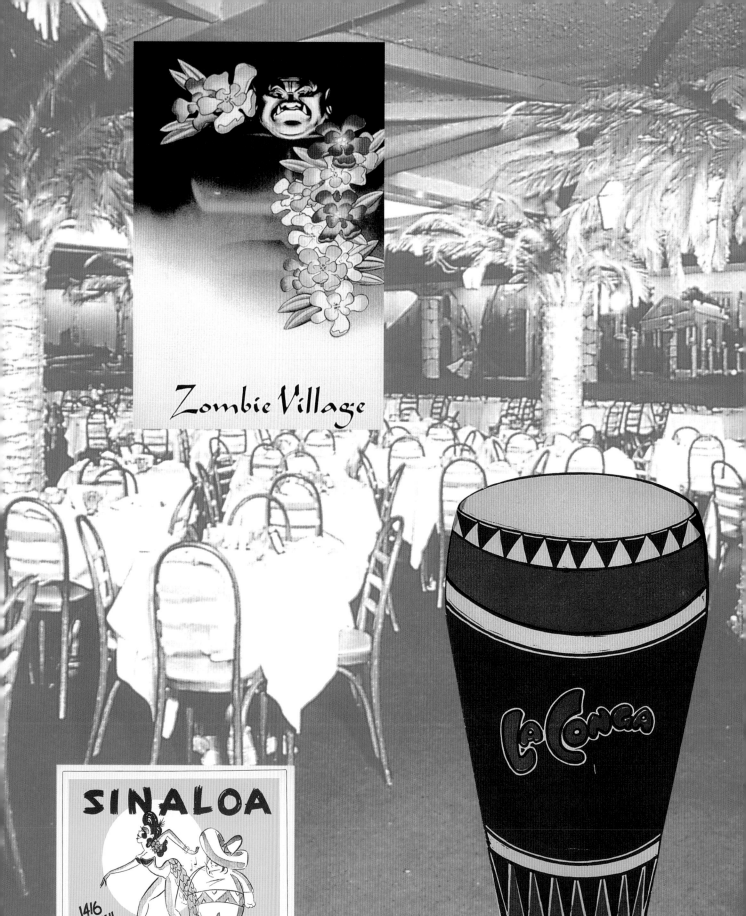

Zombie Village

SINALOA
1416 POWELL ST
SAN FRANCISCO

La Conga
BROADWAY & 51st STREET, N.Y.C.

FOREIGN CORRESPONDENT
Cuisine from Around the World

America's melting-pot tradition contributed to the wide variety of ethnic restaurants found across the country in the first part of the twentieth century. The familiar foods immigrants brought with them were soon offered in markets in most urban areas. Drawn to these large metropolitan areas because of job opportunities, newcomers quickly established restaurants in urban enclaves and then expanded as city diners responded to this increasingly cosmopolitan cuisine. Outside of urban areas resistance to ethnic food meant that it was midcentury before chain restaurants made such food palatable to a large segment of American tastes. Yet even in the 1930s, world fairs and expositions showcased a wide range of international cuisines.

In the twenties, Americans traveled in record numbers, prompting many to include eating at new and unusual places as part of their vacation and travel agendas. Duncan Hines and his popular guide to restaurants throughout the United States steered his mobile readers to many ethnic restaurants. By making them less

Opposite. Restaurants exploiting foreign themes produced equally exotic menus. Zombie Village, Oakland, California, c. 1946. Sinaloa, San Francisco, c. 1952. *Above.* Joy Young, Birmingham, Alabama, c. 1946. El Charro Cafe, Tucson, Arizona, 1943.

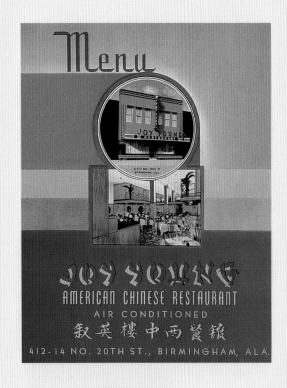

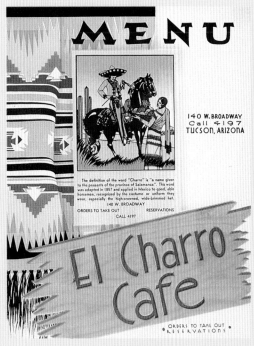

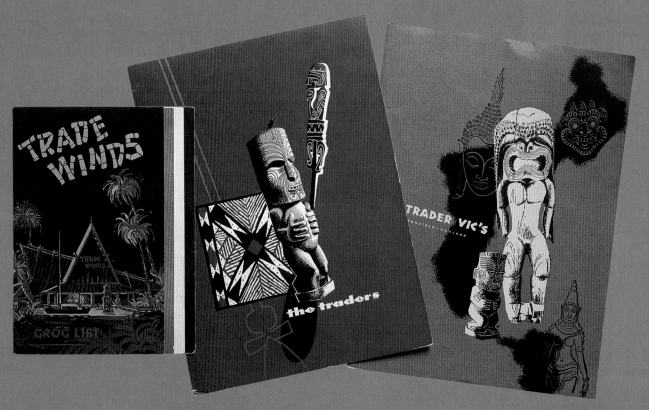

mysterious, he increased their popularity. Hawaiian and South Pacific foods received attention during the Polynesian craze of the late fifties, inspiring thousands of backyard luaus and hundreds of tiki-themed restaurants.

Commercial jetliners in the early '60s made international travel affordable and easy, expanding diners' palates. With access to foreign countries, Americans brought back new ideas about eating. Eager to duplicate overseas meals, diners sought alternatives to meat-and-potato fare and began seeking out ethnic restaurants in even greater numbers.

Graphics for ethnic restaurant menus capitalized on the visual references of a particular country or culture. Many restaurants relied on prevailing racial stereotypes for their graphics. Menu covers displayed images and caricatures that were once acceptable but are offensive today in their portrayal of race and cultural bias. These misguided parodies, distorted as they are, nonetheless accurately reflect the tastes and standards of another era.

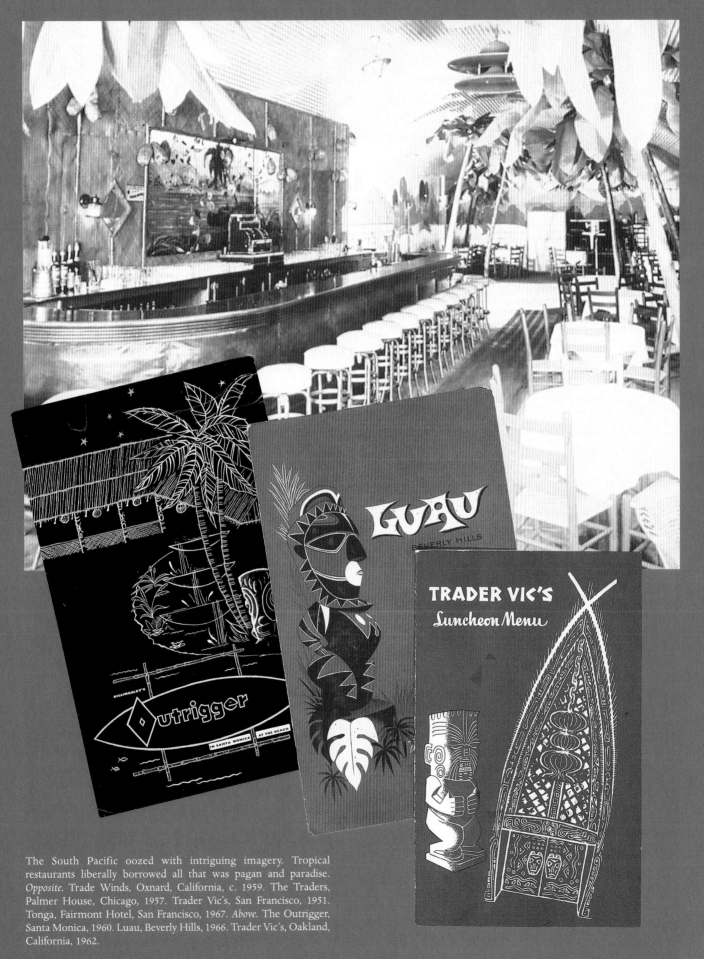

The South Pacific oozed with intriguing imagery. Tropical restaurants liberally borrowed all that was pagan and paradise. *Opposite.* Trade Winds, Oxnard, California, c. 1959. The Traders, Palmer House, Chicago, 1957. Trader Vic's, San Francisco, 1951. Tonga, Fairmont Hotel, San Francisco, 1967. *Above.* The Outrigger, Santa Monica, 1960. Luau, Beverly Hills, 1966. Trader Vic's, Oakland, California, 1962.

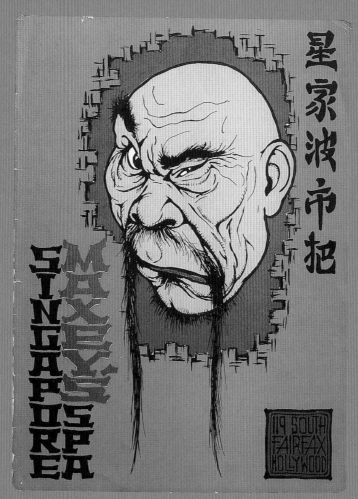

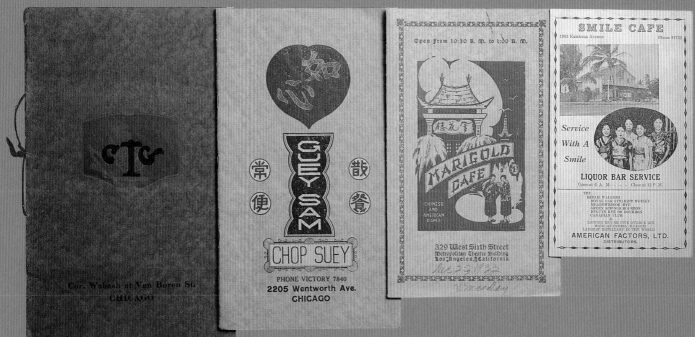

Chinese restaurants could be found in hamlets and cities across America and menu art for them mimicked the mysterious Orient through lurid caricatures and colors. *Top.* At Lau Yee Chai's in Honolulu, Hawaii, c. 1934, owner P. Y. Chong capitalized on Chinese stereotypes by writing his menu copy in pidgin English. He advised customers, "You foglet hat, coat etc., so solly no can take care." Maxey's Singapore Spa, Hollywood, c. 1937. Far East Cafe, San Francisco, c. 1938. *Bottom.* Canton Tea Garden, Chicago, c. 1918. Guey Sam, Chicago, c. 1930. Marigold Cafe, Los Angeles, 1932. Smile Cafe, Honolulu, c. 1934. *Opposite clockwise.* Forbidden Palace, Los Angeles, c. 1939. Golden Pagoda, Los Angeles, 1948. Forbidden Palace, c. 1942. Lamps of China, San Francisco, c. 1949. Chin's, New York, c. 1946. Kim Ling Inn, c. 1938.

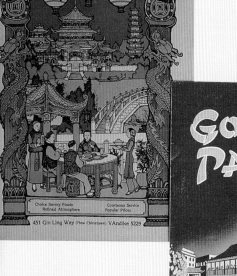

FORBIDDEN-PALACE
CHINESE FOOD AT ITS BEST
頤 和 園

Choice Savory Foods Courteous Service
Refined Atmosphere Popular Prices

451 Gin Ling Way (New Chinatown) VAndike 5229

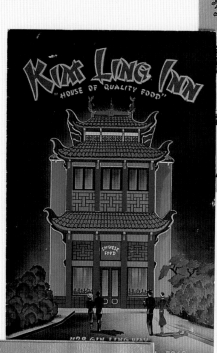

KIM LING INN
"HOUSE OF QUALITY FOOD"

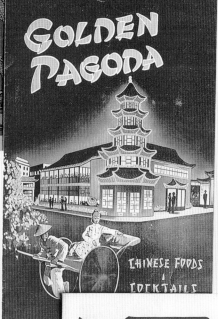

GOLDEN PAGODA

CHINESE FOODS
&
COCKTAILS

IN NEW CHINATOWN

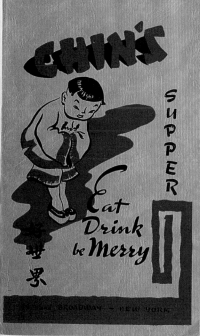

CHIN'S
SUPPER
Eat
Drink
be Merry

BROADWAY — NEW YORK

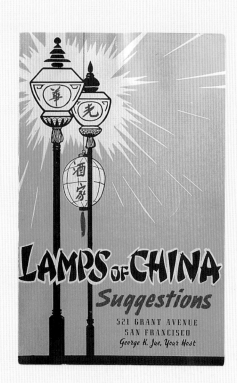

LAMPS of CHINA
Suggestions

521 GRANT AVENUE
SAN FRANCISCO
George K. Jue, Your Host

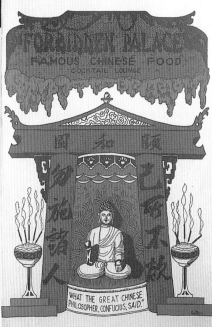

FORBIDDEN PALACE
FAMOUS CHINESE FOOD
COCKTAIL LOUNGE

頤 和 園

"WHAT THE GREAT CHINESE
PHILOSOPHER, CONFUCIUS, SAID."

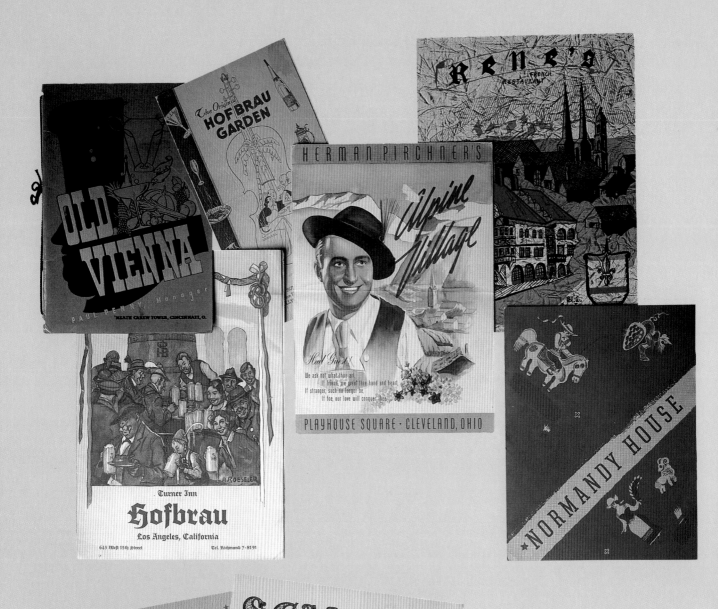

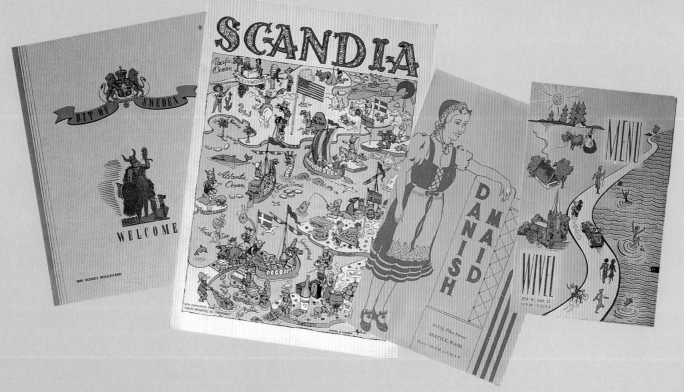

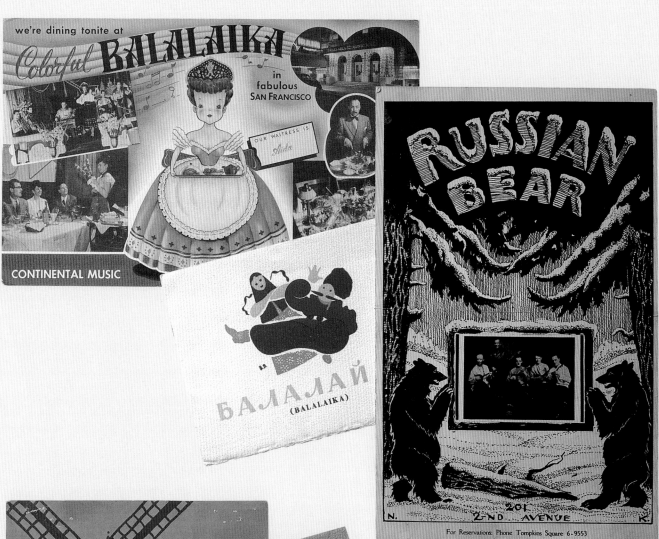

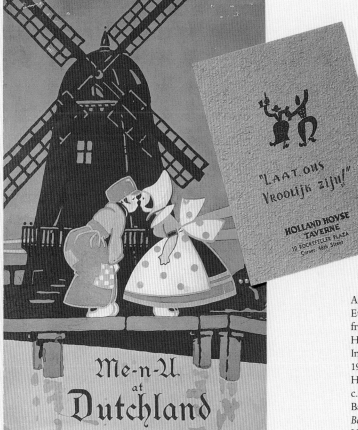

America's melting pot resulted in a mind-boggling number of European-derived cuisines and restaurants. *Opposite top.* Menu covers from Old Vienna, Cincinatti, Ohio, c. 1930. Hofbrau Garden, Hollywood, 1942. Alpine Village, Cleveland, Ohio, c. 1944. Rene's, Indianapolis, Indiana, c. 1958. Turner Inn Hofbrau, Los Angeles, c. 1962. Normandy House, c. 1939. *Opposite bottom.* Bit of Sweden, Hollywood, c. 1943. Scandia, Hollywood, c. 1960. Danish Maid, Seattle, c. 1938. Wivel, New York, 1951. *Above.* Balalaika, San Francisco, c. 1946. Balalaika, Washington D.C., 1942. Russian Bear, New York, c. 1933. *Bottom.* Dutchland Farms, Brockton, Massachusetts, c. 1939. Holland House Tavern, Rockefeller Plaza, New York, c. 1940.

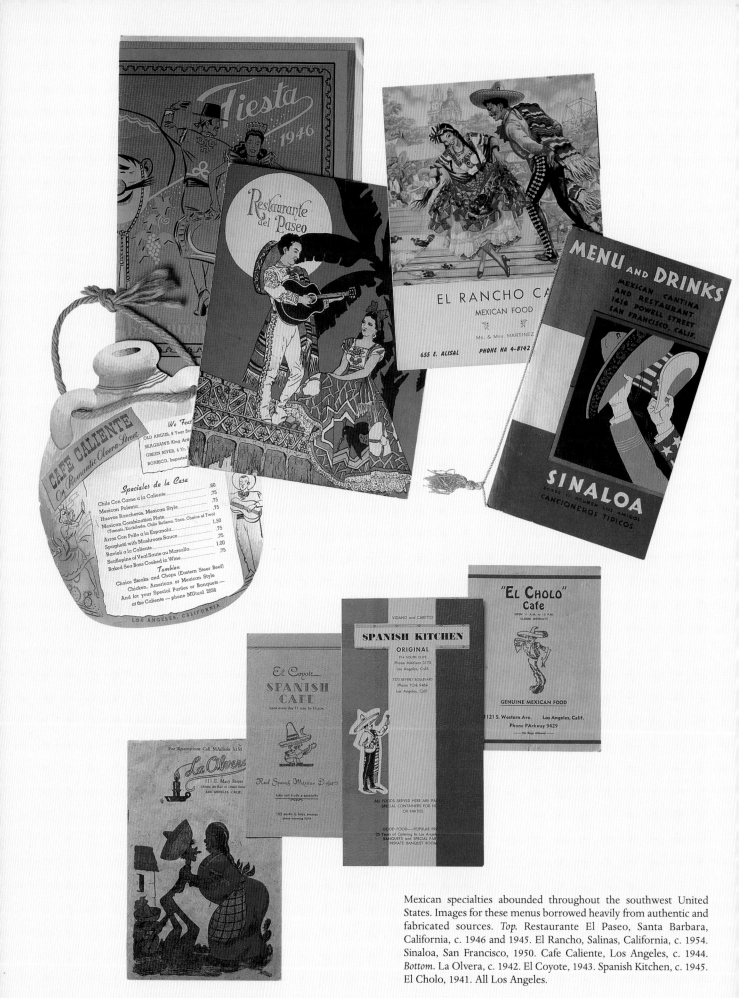

Mexican specialties abounded throughout the southwest United States. Images for these menus borrowed heavily from authentic and fabricated sources. *Top.* Restaurante El Paseo, Santa Barbara, California, c. 1946 and 1945. El Rancho, Salinas, California, c. 1954. Sinaloa, San Francisco, 1950. Cafe Caliente, Los Angeles, c. 1944. *Bottom.* La Olvera, c. 1942. El Coyote, 1943. Spanish Kitchen, c. 1945. El Cholo, 1941. All Los Angeles.

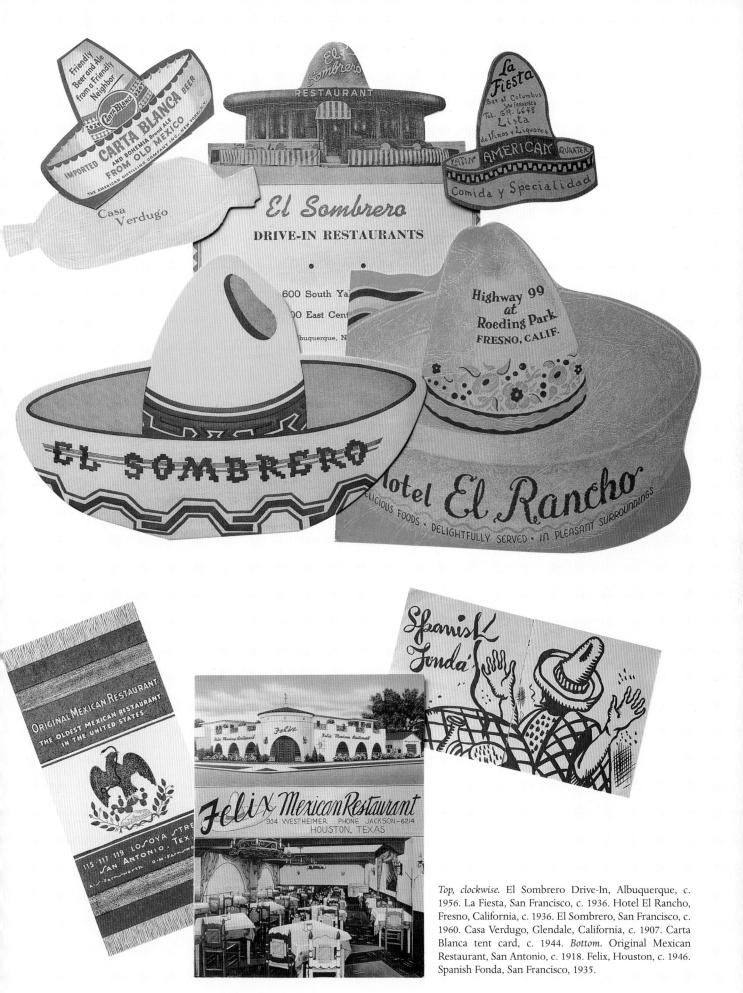

Top, clockwise. El Sombrero Drive-In, Albuquerque, c. 1956. La Fiesta, San Francisco, c. 1936. Hotel El Rancho, Fresno, California, c. 1936. El Sombrero, San Francisco, c. 1960. Casa Verdugo, Glendale, California, c. 1907. Carta Blanca tent card, c. 1944. *Bottom.* Original Mexican Restaurant, San Antonio, c. 1918. Felix, Houston, c. 1946. Spanish Fonda, San Francisco, 1935.

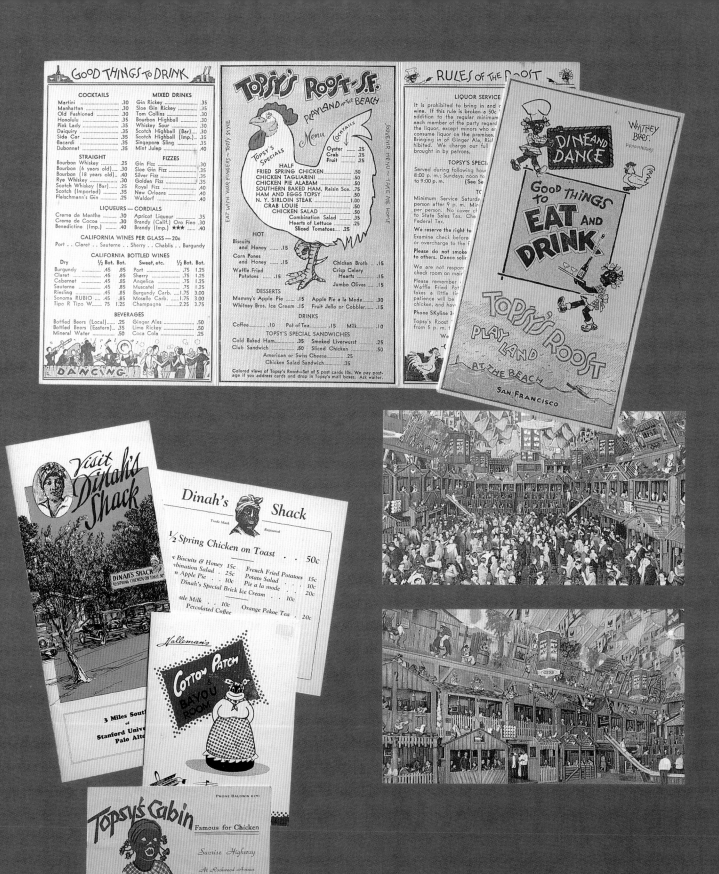

Up until the 1960s, authentic African American cuisine was forfeited for a broader menu. Images for these restaurants reflected prevailing racial attitudes and black stereotypes. *Top and right.* Topsy's Roost, San Francisco, c. 1935. *Above.* Dinah's Shack, Palo Alto, California, c. 1938. Cotton Patch, San Diego, c. 1950. Topsy's Cabin, Baldwin, Long Island, c. 1939. *Opposite.* More adventures in European inspired dining. *Top.* Paramount Italian Kitchen, Hollywood, c. 1943. Italian Kitchen, Hollywood, c. 1946. Ernie's, San Francisco, c. 1934. *Bottom.* Spanish Village, Washington D.C., c. 1932. Hacienda, c. 1941. Spanish Shop, c. 1931. La Palma Patio, 1936. Casa de Sevilla, Santa Barbara, c. 1935.

PARAMOUNT
ITALIAN KITCHEN
RIGHT IN THE HEART
OF THE
RADIO
CAPITOL
OF THE
WORLD
PARAMOUNT ITALIAN KITCHEN
6270 SUNSET BLVD.
HOLLYWOOD, CALIFORNIA

Italian Kitchen

847 MONTGOMERY STREET
SAN FRANCISCO, CALIFORNIA

EXbrook 9846

In the Heart of
San Francisco's Bohemia

Ernie's

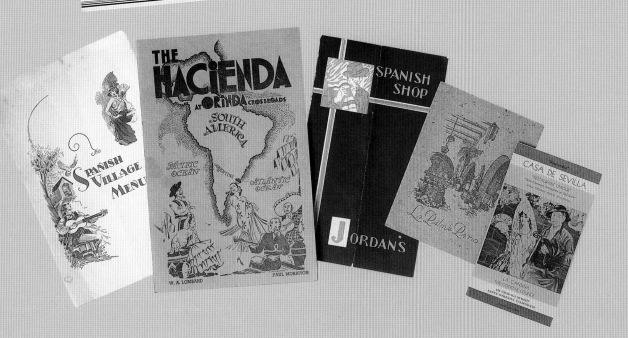

The Spanish Village Menu

THE HACIENDA AT ORINDA CROSSROADS
SOUTH AMERICA
PACIFIC OCEAN
ATLANTIC OCEAN

W. A. LOMBARD PAUL MORRISON

SPANISH SHOP

JORDAN'S

La Palma Patio

CASA DE SEVILLA
RESTAURANT UNIQUE

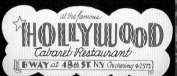

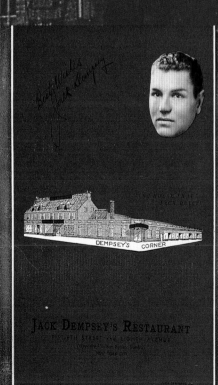

STAR STRUCK
Celebrity-Inspired Menus

The combination of famous people and an evening of fine dining was a formula that spelled instant success for many restaurants that catered to celebrities. Celebrity was, without question, one of a restaurant's best draws. The chance to mingle with a luminary or star could be the ultimate enticement to dining out.

The menus for many of these restaurants, bars, and nightclubs became barometers of high style. Complex printing, specialized embossing, unique paper stock, and other devices were marshaled to create a memorable dining experience. Menu size was another key element, and the oversize menu was a celebrity restaurant staple. The larger the menu, the reasoning went, the more important a restaurant was, given the seemingly limitless comestibles that they could offer. In addition, a separate wine list and cocktail menu were often available. Benefits and special events contributed to the creation of celebrity restaurant menus, providing opportunities for one-of-a-kind designs. Visiting dignitaries at the Waldorf Astoria might warrant a

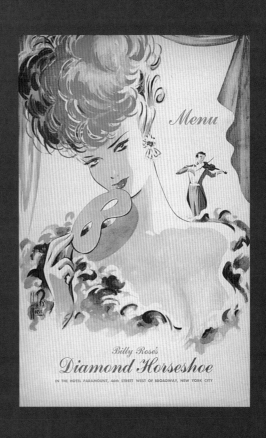

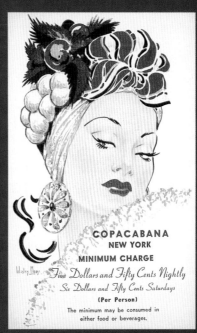

Hoping to catch a glimpse of a celebrity or two, visitors to the Big Apple sought out clubs and restaurants frequented or owned by the city's rich and famous. Menus from the top places were treasured souvenirs. Among them were the following. *Opposite.* Reuben's, c. 1952. Jack Dempsey's, c. 1935. Hollywood Cabaret, c. 1934. *Above.* Diamond Horseshoe, 1950. Copacabana, c. 1954.

89

commemorative menu festooned with ribbons and flags. The Academy Awards might commission a special program/menu for its celebration at the Coconut Grove, or a philanthropic group such as the film colony's Mayflower Club might sponsor a dance calling for an elaborate menu.

Sports personalities such as Jack Dempsey, Slapsy Maxie, and Joe DiMaggio were unabashed in using their fame to lure customers to their establishments. They incorporated their image on the menu cover, creating an instant demand for it as a souvenir. In an early licensing ploy, companion products were offered as gift items. Likewise, other high-profile spots such as the Stork Club, Ciro's, and the Brown Derby added various product lines including cuff links, necklaces, salad dressing, and whatever else was at the cashier's booth. Sugies Tropics, on tony Rodeo Drive in Beverly Hills, named drinks on their souvenir cocktail menu after celebrity clientele. Tourists ate it up. Who could resist telling the folks back home of sipping a "Dorothy Lamour" in the company of Hollywood's brightest?

In the movie-making capital, within the confines of the studio walls, commissaries or cafeterias were the place to get a meal quickly. Depending on the size of the studio, these on-site restaurants could be modest diners or full-fledged enterprises with custom plates, silverware, and elaborate interiors. The latter were usually reserved for the stars, executives, and visiting dignitaries. Commissary menu covers tended to be more modest than one would expect from a Hollywood institution. At MGM, however, many special food items were named after personalities or motion pictures associated with the studio.

Though New York and Hollywood dominated celebrity restaurant lists, other cities also shared in the limelight: Miami, Atlantic City, Nashville, New Orleans, and San Francisco drew known stars and big-name bands to restaurants and nightclubs. Las

Vegas, with its rambling hotels and casinos, eclipsed standard hot spots such as Hollywood's Sunset Boulevard and New York's Broadway. The Sands, Flamingo, Dunes, and others booked top talent while other celebs flocked to enjoy the shows. Las Vegas menu covers rarely featured a celebrity, but focused instead on Western themes and hotel imagery. One exception was Elvis Presley. His stints at the Las Vegas Hilton in the late sixties and early seventies not only capitalized on his celebrity but were responsible for a number of products bearing his image.

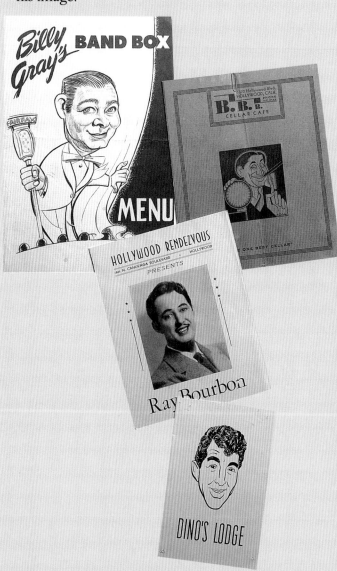

Hollywood was a beehive of celebrity activity. Restaurants and nightclubs catered to stars that were found on almost every boulevard and street. *Above.* Billy Gray's Band Box, c. 1950. B.B.B. Cellar, 1930. Hollywood Rendezvous, c. 1938. Dino's Lodge, c. 1960. *Opposite.* Florentine Gardens on Hollywood Boulevard featured a dinner show with partially nude showgirls.

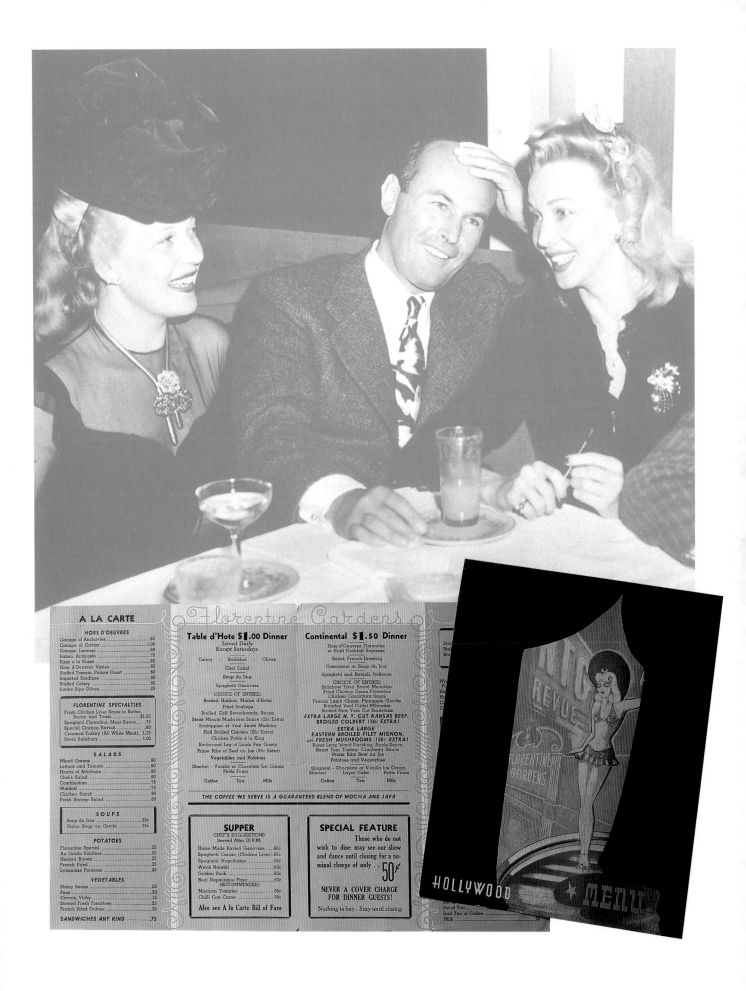

A LA CARTE

HORS D'OEUVRES
Canape of Anchovies	.60
Canape of Caviar	1.00
Canape Lorenzo	.60
Italian Antipasto	.75
Eggs a la Russe	.60
Hors d'Oeuvres Variee	.80
Stuffed Tomato, Palace Court	.60
Imported Sardines	.60
Stuffed Celery	.60
Jumbo Ripe Olives	.25

FLORENTINE SPECIALTIES
Fresh Chicken Liver Saute in Butter, Bacon and Toast	$1.25
Spaghetti Florentine, Meat Sauce	.75
Special Chicken Ravioli	.80
Creamed Turkey (All White Meat)	1.25
Steak Salisbury	1.00

SALADS
Mixed Greens	.60
Lettuce and Tomato	.60
Hearts of Artichoke	.60
Chef's Salad	.60
Combination	.75
Waldorf	.75
Chicken Salad	.80
Fresh Shrimp Salad	.80

SOUPS
Soup du Jour	.25c
Onion Soup au Gratin	.35c

POTATOES
Florentine Special	.25
Au Gratin Potatoes	.25
Hashed Brown	.25
French Fried	.25
Lyonnaise Potatoes	.25

VEGETABLES
String Beans	.20
Peas	.20
Carrots, Vichy	.15
Stewed Fresh Tomatoes	.25
French Fried Onions	.25

SANDWICHES ANY KIND .75

Florentine Gardens

Table d'Hote $1.00 Dinner
Served Daily Except Saturdays

Celery · Radishes · Olives

Chef Salad

Soup du Jour

Spaghetti Genovese

CHOICE OF ENTREE:
Broiled Halibut, Maitre d'Hotel
Fried Scallops
Broiled Calf Sweetbreads, Bacon
Steak Minute Mushroom Sauce (25c Extra)
Scaloppine of Veal Sauté Madeira
Half Broiled Chicken (25c Extra)
Chicken Pattie à la King
Barbecued Leg of Lamb Pan Gravy
Prime Ribs of Beef au Jus (25c Extra)

Vegetables and Potatoes

Sherbet · Vanilla or Chocolate Ice Cream
Petits Fours

Coffee Tea Milk

Continental $1.50 Dinner

Hors d'Oeuvres Florentine
or Fruit Cocktail Supreme

Salad, French Dressing

Consommé or Soup du Jour

Spaghetti and Ravioli, Italiene

CHOICE OF ENTREE:
Rainbow Trout Sauté Meuniére
Fried Chicken Doree Florentine
Chicken Cacciatora Sauce
French Lamb Chops, Pineapple Glacée
Breaded Veal Cutlet Milanaise
Broiled New York Cut Bordelaise
**EXTRA LARGE N. Y. CUT KANSAS BEEF,
BROILED COLBERT (50c EXTRA)**
**EXTRA LARGE
EASTERN BROILED FILET MIGNON,
with FRESH MUSHROOMS (50c EXTRA)**
Roast Long Island Duckling, Apple Sauce
Roast Tom Turkey, Cranberry Sauce
Prime Ribs Beef au Jus
Potatoes and Vegetables

Spumoni · Chocolate or Vanilla Ice Cream
Sherbet Layer Cake Petits Fours

Coffee Tea Milk

THE COFFEE WE SERVE IS A GUARANTEED BLEND OF MOCHA AND JAVA

SUPPER
*CHEF'S SUGGESTIONS
Served After 10 P.M.*

Home Made Ravioli Genovese	.60c
Spaghetti Caruso (Chicken Liver)	.65c
Spaghetti Napolitaine	.50c
Welsh Rarebit	.50c
Golden Buck	.60c
Real Napolitaine Pizza (RECOMMENDED)	.50c
Mexican Tamales	.65c
Chilli Con Carne	.55c

Also see A la Carte Bill of Fare

SPECIAL FEATURE

Those who do not wish to dine and see our show and dance until closing for a nominal charge of only . . **50¢**

NEVER A COVER CHARGE FOR DINNER GUESTS!

Nothing to buy · Stay until closing

HOLLYWOOD · MENU

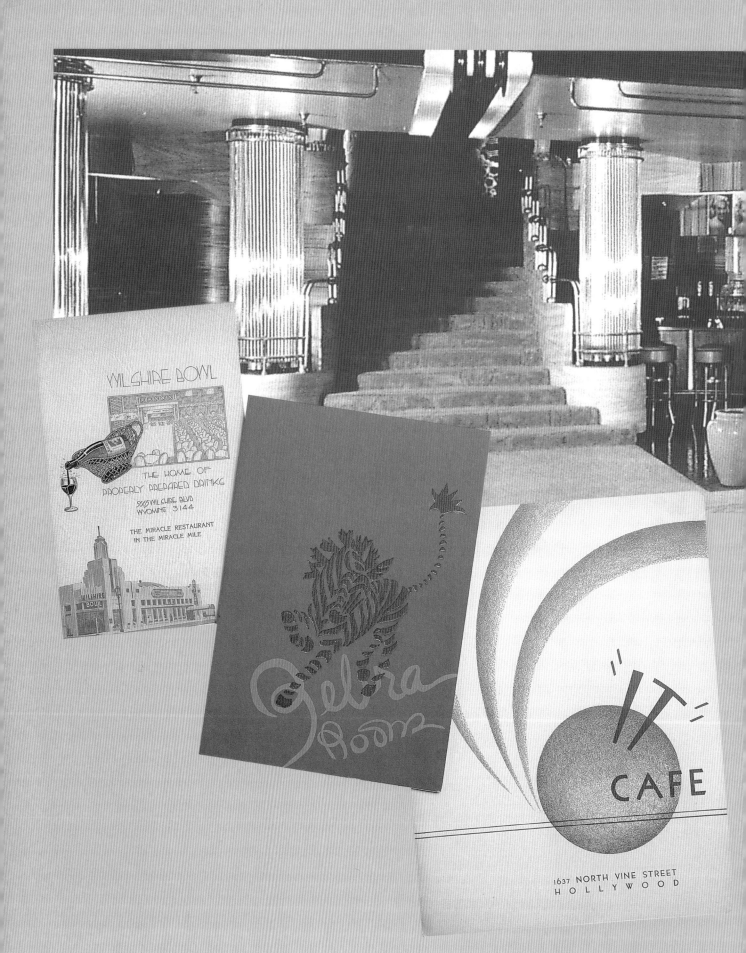

WILSHIRE BOWL

THE HOME OF
PROPERLY PREPARED DRINKS

5665 WILSHIRE BLVD.
WYOMING 3144

THE MIRACLE RESTAURANT
IN THE MIRACLE MILE

WILSHIRE
BOWL

Zebra
Room

IT
CAFE

1637 NORTH VINE STREET
HOLLYWOOD

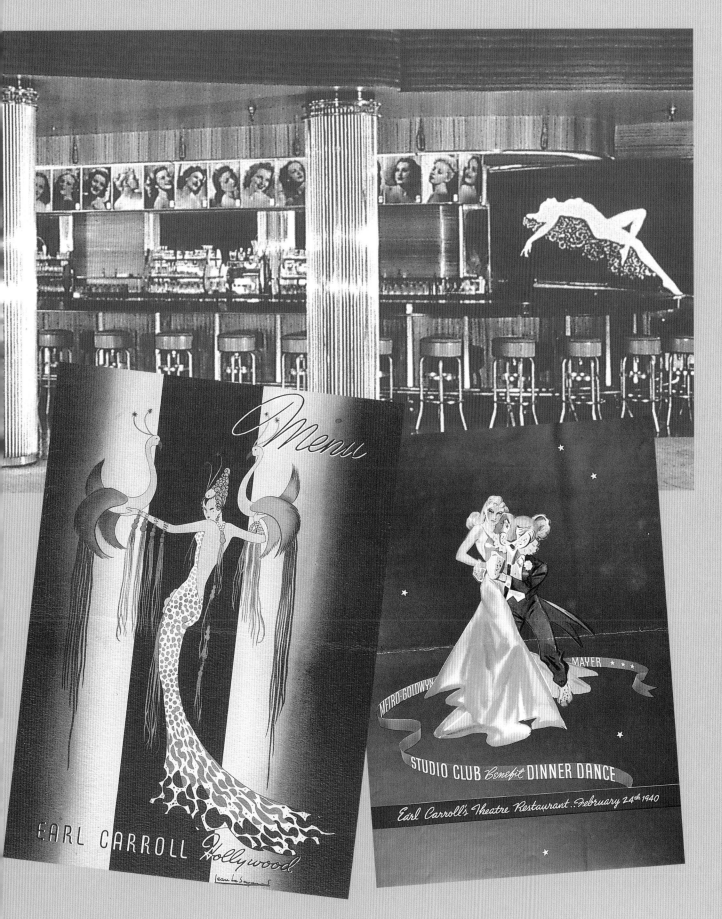

Opposite. Wilshire Bowl, c. 1940. Zebra Room, c. 1942. Clara Bow's "It" Cafe, c. 1937. *Above.* Showplace of the stars, Earl Carroll's giant menu, c. 1939. Special comemmorative menu for the M.G.M. Studio Club dinner dance, 1940.

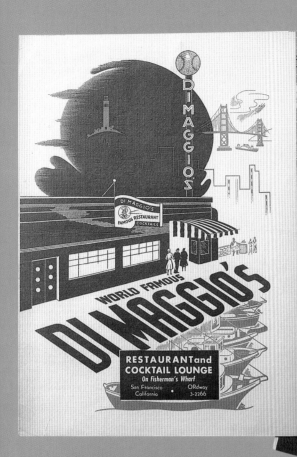

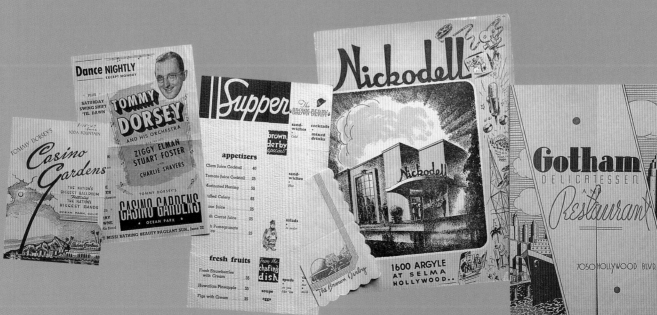

Above. With his family, Joe DiMaggio turned his seafood restaurant into one of San Francisco's main tourist attractions, c. 1940–1954. Hollywood celebs and their fans could be found scanning menus from a variety of pricey and down-home restaurants. *Below.* Tommy Dorsey's Casino Gardens, Ocean Park, c. 1946. Brown Derby, c. 1936. Nickodell, c. 1952. Gotham Delicatessen, c. 1940.

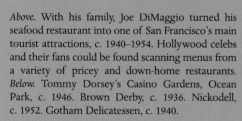

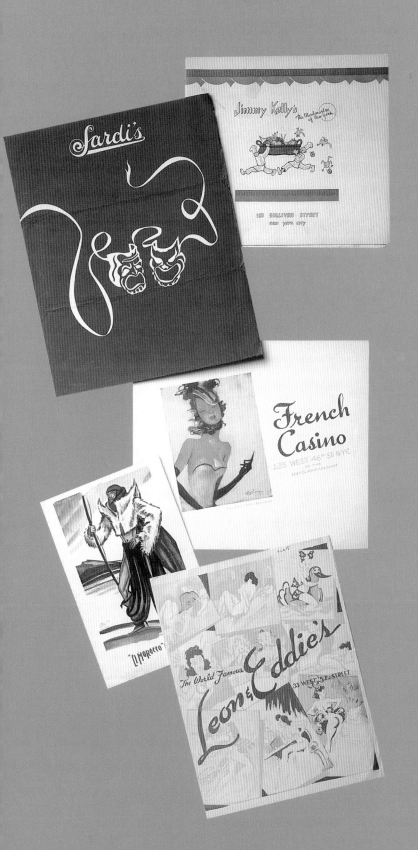

on the Flaming Sword!

From coast to coast well-known personalities were able to dine in elegance, accompanied, of course, by distinctive menus. *Left.* Menus from some New York hot spots. Jimmy Kelly's, c. 1939. Sardi's, 1950. French Casino, c. 1948. El Morocco, 1937. Leon and Eddie's Stork Club, c. 1949. *Above.* The Pump Room in Chicago's Ambassador Hotel was the top choice for celebs visiting the Windy City, c. 1941.

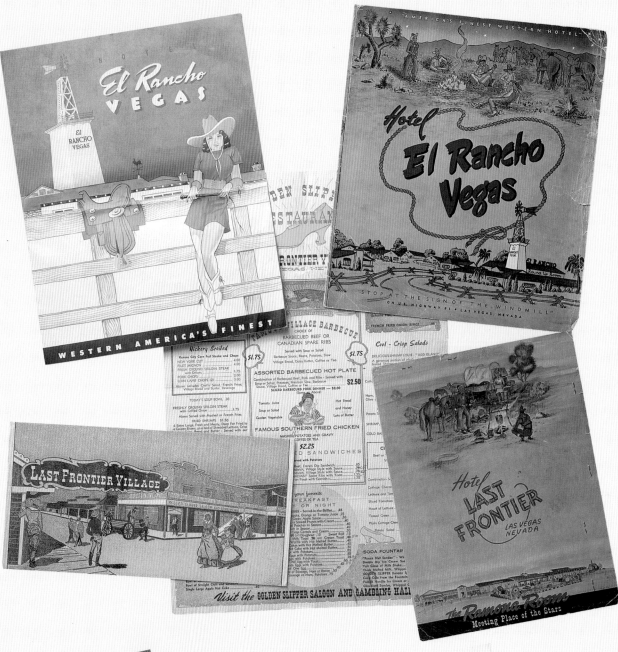

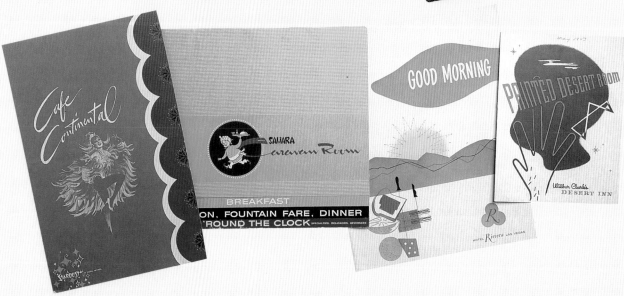

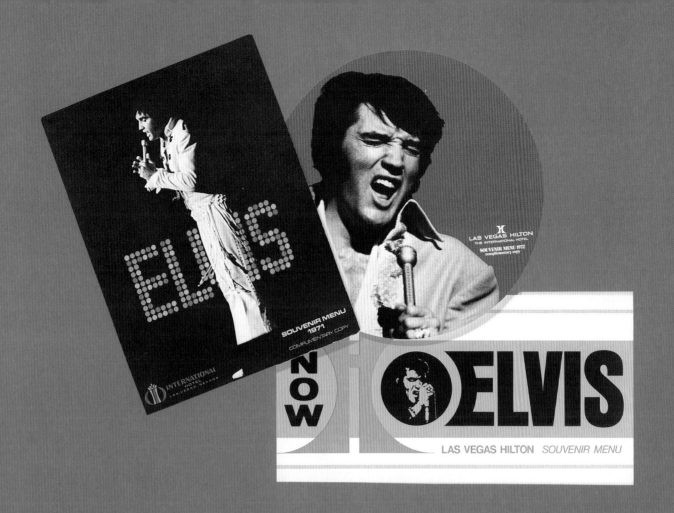

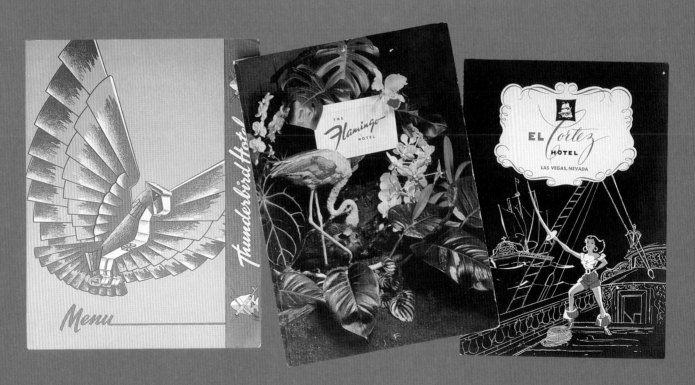

Las Vegas was a desert mecca drawing top-name talent to casinos that catered to gamblers as well as audiences hungry for entertainment. Hotels competed with each other, creating a barrage of newly minted graphics year after year. *Opposite top, clockwise.* El Rancho Vegas, c. 1949 and 1951. Last Frontier, 1946. Golden Slipper, 1951. *Opposite bottom.* Cafe Continental, Stardust Hotel, c. 1962. Sahara Hotel, c. 1960. Riviera Hotel, c. 1956. Desert Inn, 1953. *Above.* Elvis at the International Hotel, 1971. Hilton Hotel, 1972 and 1973. Thunderbird Hotel, c. 1954. Flamingo Hotel, c. 1953. El Cortez Hotel, c. 1952.

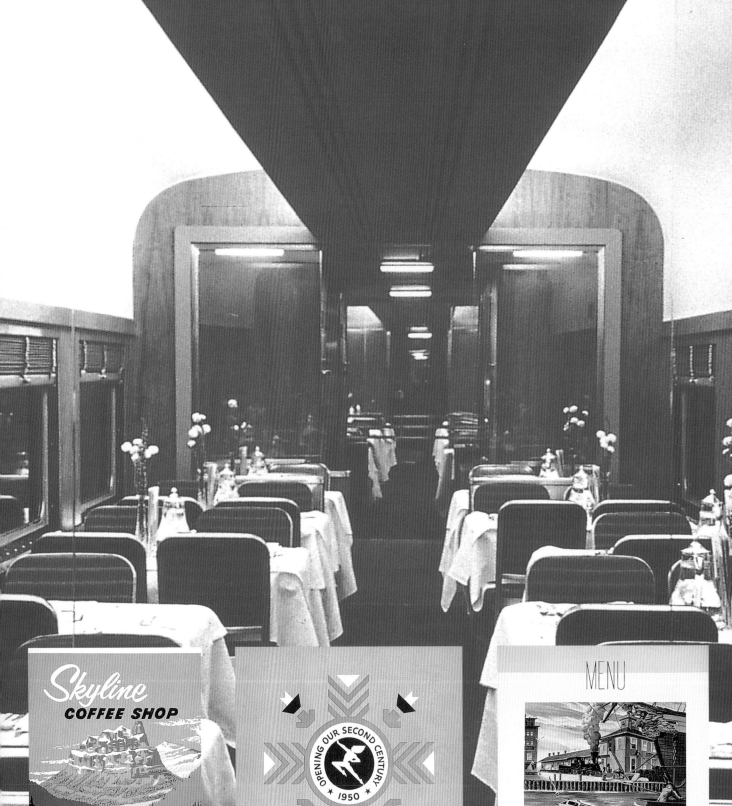

Skyline
COFFEE SHOP

CANADIAN PACIFIC

OPENING OUR SECOND CENTURY
1950

Hiawatha
THE MILWAUKEE ROAD

MENU

A Century of North Western Service! The pioneer, in 1848 the first locomotive in Chicago and the West, shown at Chicago's first railroad station. It is the ancestor of North Western's modern "400" streamliners.

CHICAGO and NORTH WESTERN SYSTEM
PIONEER RAILROAD OF CHICAGO AND THE WEST
Since 1848

BY LAND, BY AIR, BY SEA
Transportation Menus

The first dining service on a train was initiated in 1862, in a converted baggage car. The menu featured oysters, crullers, and coffee. By the 1880s, George Pullman had dining cars on railroads crisscrossing the United States, serving repasts that might include wild turkey, Lake Superior whitefish, or fifteen kinds of bread. In the early twentieth century, travel by rail was refined and unhurried; dining service followed those precepts. A printed menu always listed an amazing variety of dishes, considering most items were prepared while in transit. In addition to the regular breakfast, lunch, and dinner menus, many railroads offered specialized children's menus and cocktail lists.

Cover motifs for many of the dining car menus evoked the terrain the train traveled through: photographs of mountain ranges, deserts, rivers, or resorts along the rails were pleasant reminders of the view outside a club or dining car window. Regional distinctions were also popular. A series for the Great Northern Railroad of American Indians in tribal garb was an

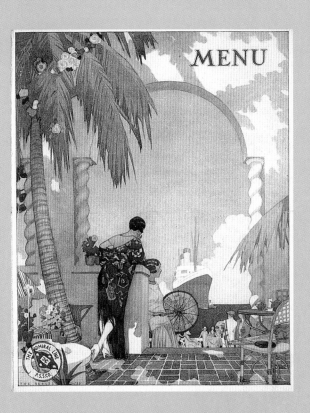

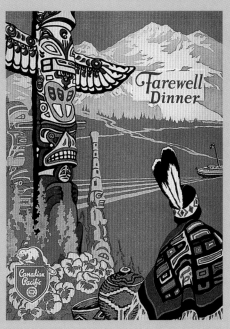

Travelers were treated to deluxe meals and menus before the jet age. *Opposite.* Memorable dining car memories via menus from Canadian Pacific Railroad, 1965. Milwaukee Railroad, Hiawatha, 1950. Chicago and North Western Railroad, 1948. *Above.* H.F. *Alexander*, Pacific Steamship Company, 1929. S.S. *Princess Louise*, 1951.

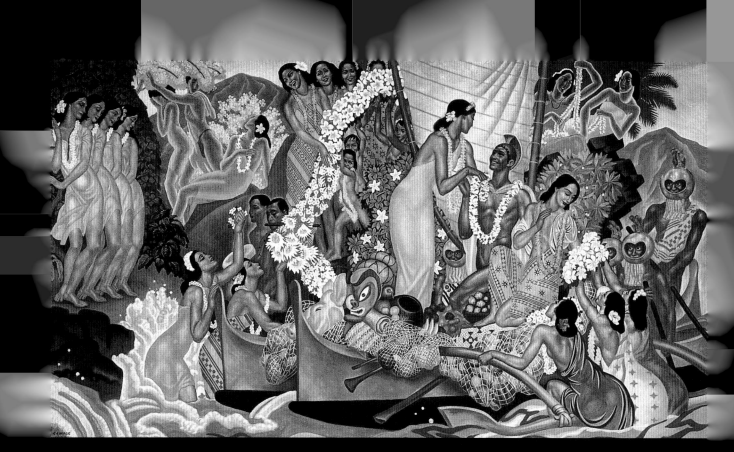

often-kept souvenir. Club car menus retained a sophisticated image, emphasizing the elegant cocktail lounge atmosphere where travelers could converse, smoke, play cards, and enjoy light snacks.

With the rise of air travel during the 1950s, passenger rail service began a slow decline. By the 1960s most major routes had been curtailed, and the once preferred choice of transportation for millions of Americans became more a memory than a travel option.

American Airlines introduced in-flight meals in 1936. The romance and glamour associated with early air travel provided an opportunity to design menus that were compact and straightforward for easy handling. The covers had images that might include flight destinations, corporate logos, or decorative maps. When Northwest Airlines inaugurated cocktail service in the air in 1949, beverage menus were also provided to passengers, reflecting a time when the cost of air travel limited its access to most Americans. As the popularity of flying increased dramatically with the introduction of affordable jet travel, meal quality declined for coach passengers. Eventually printed menus were abandoned as meal choices diminished. Menus in first-class sections remain, but the demise of good in-flight meals make vintage airline menus artifacts of another era.

In the early part of the century, dining aboard ships reached new heights as luxury liners traveled the seas in record numbers. Limited to travelers

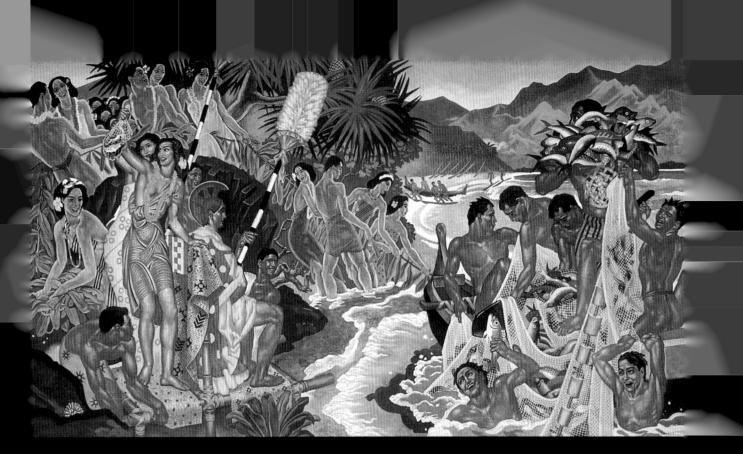

who could afford first-class travel, dining at sea remained a formal and memorable experience. Menus for these shipboard dinners reflected this elegance until the 1920s, when cruises on smaller American ship lines became more casual. While dining service still retained an aura of importance, more emphasis was given to informal activities and varied fare. Reflecting this, menu covers became more decorative, illustrating deck activities such as shuffleboard or sunning.

Ships such as Cunard's Queen Mary and the French Line's Normandy featured the Art Deco–inspired details of their interiors and paintings on some of their menus. Several domestic liners incorporated similar period design elements, producing menus immensely popular with passengers. By far the most popular type of cover featured a destination. Exotic lands and landmarks were given wide exposure on many covers. Hawaiian themes on Matson Lines menus were perennial favorites, as were the Great White Fleet Caribbean cruises in the mid-thirties, which pictured graceful dolphins and stately parrots.

Because of the specialized nature of cruise ships, menus were designed to be kept as souvenirs. Menus commemorating an equator crossing or holiday were quickly snatched up as keepsakes. The popularity of the menu, not only as a listing of food but as a pleasant reminder of vacation memories demonstrates the enduring nature of this category of menu design.

A sea voyage to Hawaii was complemented by these spectacular menu graphics. *Top.* Matson Lines, Eugene Savage,

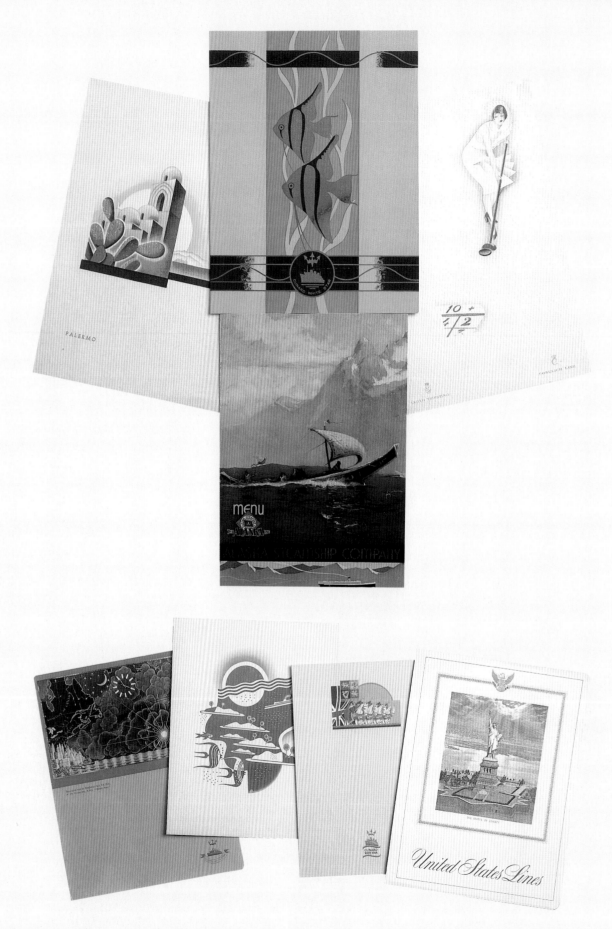

The pleasure of a relaxing cruise is evident in these various ship menus spanning several decades of design dictates. *Opposite.* Special events aboard ship called for custom menus to mark the occasion.

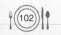

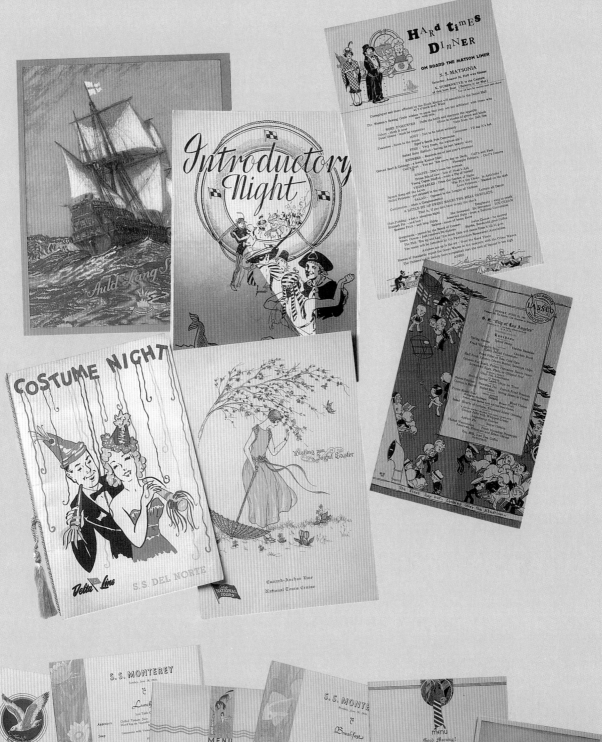
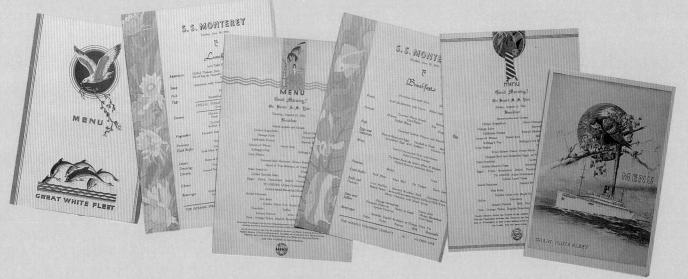

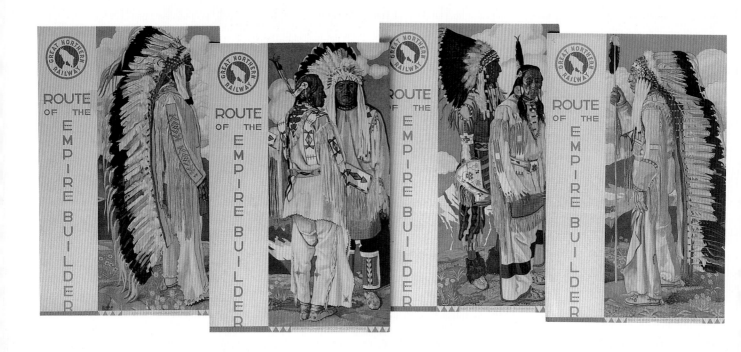

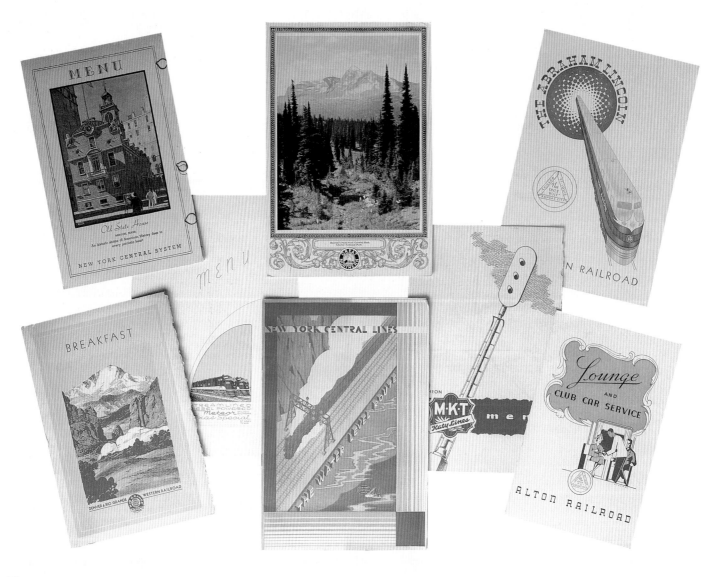

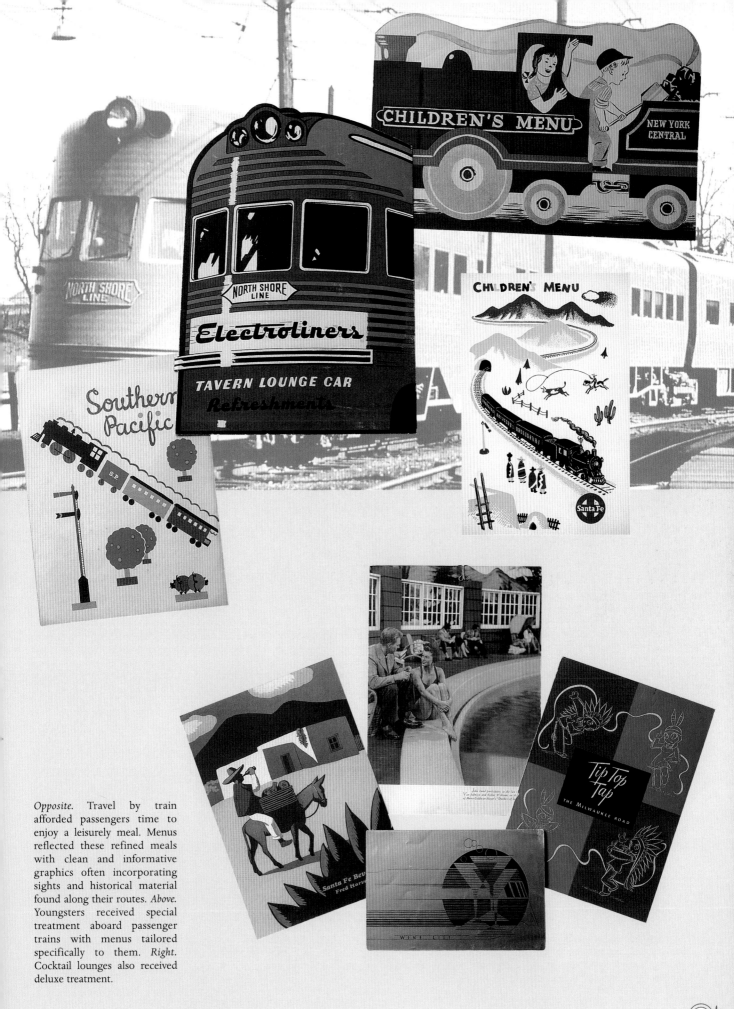

Opposite. Travel by train afforded passengers time to enjoy a leisurely meal. Menus reflected these refined meals with clean and informative graphics often incorporating sights and historical material found along their routes. *Above.* Youngsters received special treatment aboard passenger trains with menus tailored specifically to them. *Right.* Cocktail lounges also received deluxe treatment.

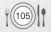

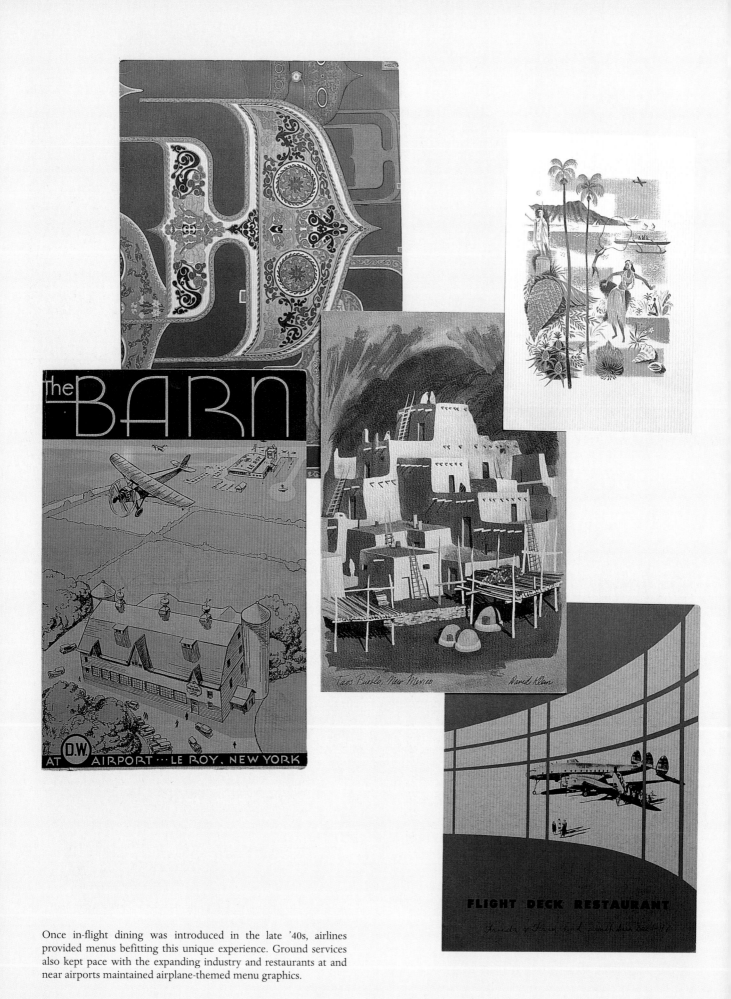

Once in-flight dining was introduced in the late '40s, airlines provided menus befitting this unique experience. Ground services also kept pace with the expanding industry and restaurants at and near airports maintained airplane-themed menu graphics.

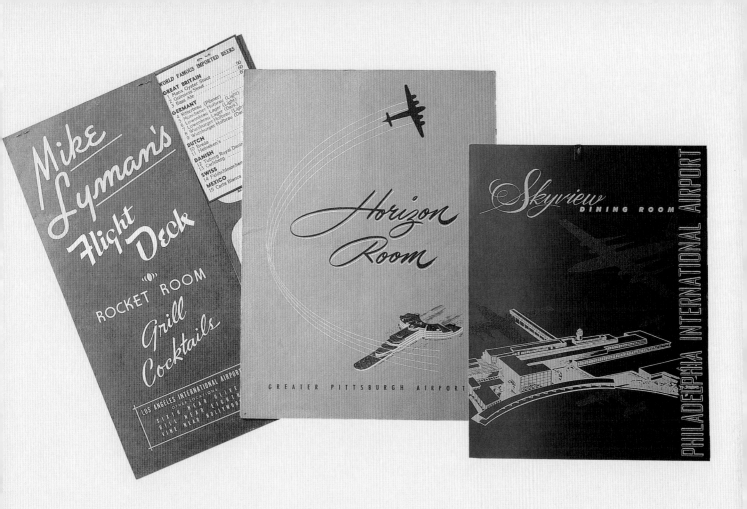

WORLD FAMOUS IMPORTED BEERS

	50	60
GREAT BRITAIN		
1 Mann Oyster Stout		
2 Guinness Stout		
3 Bass Ale		
GERMANY		
4 Kirschbrau (Pilsner)		
5 Munchener Hofbrau (Light)		
6 Lowenbrau Lager (Dark)		
6 Lowenbrau Lager (Light)		
7 Wurzburger Hofbrau (Dark)		
DUTCH		
10 Breda		
11 Heineken's		
DANISH		
12 Tuborg Royal Danish		
13 Carlsberg		
SWISS		
14 Feldschlosschen		
MEXICO		
15 Carta Blanca		

Mike Lyman's Flight Deck
ROCKET ROOM
Grill
Cocktails

LOS ANGELES INTERNATIONAL AIRPORT
OTHER LOCATIONS
SIXTH NEAR OLIVE
HILL NEAR EIGHTH
VINE NEAR HOLLYWOOD

Horizon Room
GREATER PITTSBURGH AIRPORT

Skyview DINING ROOM
PHILADELPHIA INTERNATIONAL AIRPORT

FROM THE Skychef BAR

THE NONSTOP Mercury MENU
A A
Symbol of Service
FIRST NONSTOP COAST TO COAST SERVICE

Menu

The Statesman menu
First Nonstop Service
Washington-Los Angeles

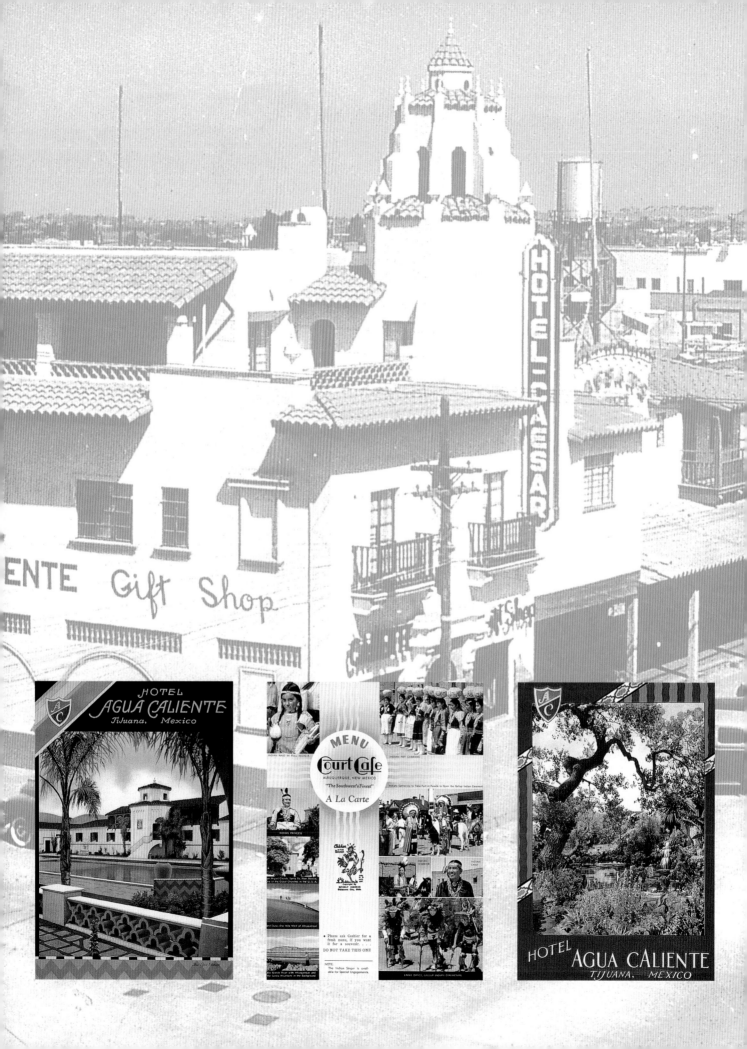

CHAPTER 9

ON THE ROAD
Menus Along the Highway

America's love affair with the automobile put millions of drivers on the highway. The lure of the asphalt was closely followed by restaurants that provided meals and provisions to hungry travelers. As these roadside amenities sprouted up, a new type of menu developed that drew upon the power of association with this new found freedom. Regional references were an appealing choice for many restaurant owners who generously appropriated mythic and real images of nearby geography for menu art. Western themes in particular had broad interest, and the images of wide-open space and frontier spirit connected easily with the vagabond traveler.

The drive-in restaurant was a roadside type that adapted to the sort of graphics that mirrored highway architecture. Neon bright and brassy, these cafe menus dealt directly with dining in the car and grabbing a motorist's attention, providing the genre with some of the best examples of menu design.

Automobiles meant travel to Americans and they hit the road with a vengeance. Whether across the country or across the border, restaurants catered to travelers along the highway and in the towns and cities they visited. *Opposite*. Menus from Agua Caliente, c. 1932, near Tijuana, Mexico, a favored American resort. The Court Cafe on Route 66 in Albuquerque, c. 1948. *Above*. The Liberty Cafe, Route 66, Albuquerque, c. 1945. El Rancho Hotel, Fresno, California, c. 1954. *Photograph, opposite*. Hotel Caesar, Tijuana, Mexico. Birthplace of the Caesar salad.

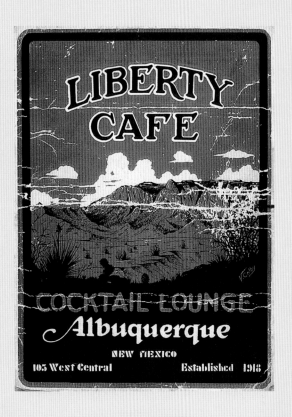

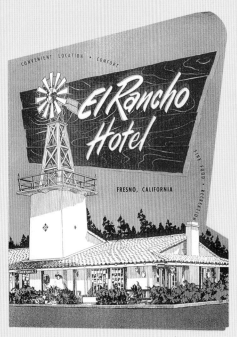

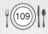

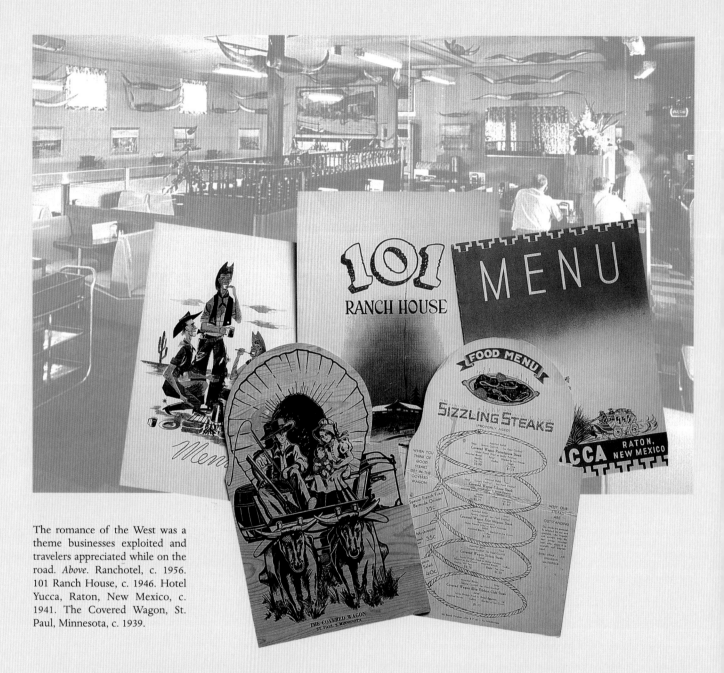

The romance of the West was a theme businesses exploited and travelers appreciated while on the road. *Above*. Ranchotel, c. 1956. 101 Ranch House, c. 1946. Hotel Yucca, Raton, New Mexico, c. 1941. The Covered Wagon, St. Paul, Minnesota, c. 1939.

In the quest for the tourist dollar, hotel and motel restaurants drew upon prior experience to attract customers to their venues. Hotel restaurants, less dependent on the auto patron, were graphically on a par with competitive roadside eateries when it came to menu design. They also had the advantage of providing room service meals accompanied, of course, by a menu.

The Fred Harvey organization, in conjunction with the railroad, created a whole series of restaurants throughout the Southwest in an early formation of the chain concept. Howard Johnson's also spread their units along the American road, becoming a familiar and comfortable stop.

Beyond the borders of the United States travelers found their eating experiences enhanced by equally exciting menu covers, which they eagerly scooped up as souvenirs. The best of these paper memories give an indication of the quality and varied graphic treatments that existed in other parts of the world.

Whether on the road or abroad, menus that served a mobile public were a winning combination of unique artwork and practical culinary signboard.

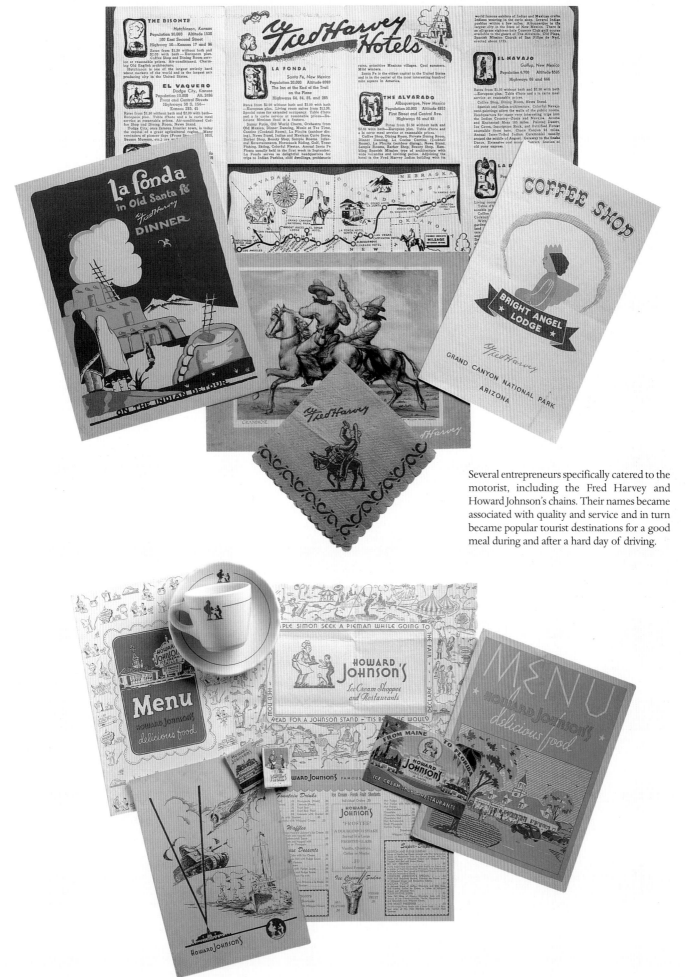

Several entrepreneurs specifically catered to the motorist, including the Fred Harvey and Howard Johnson's chains. Their names became associated with quality and service and in turn became popular tourist destinations for a good meal during and after a hard day of driving.

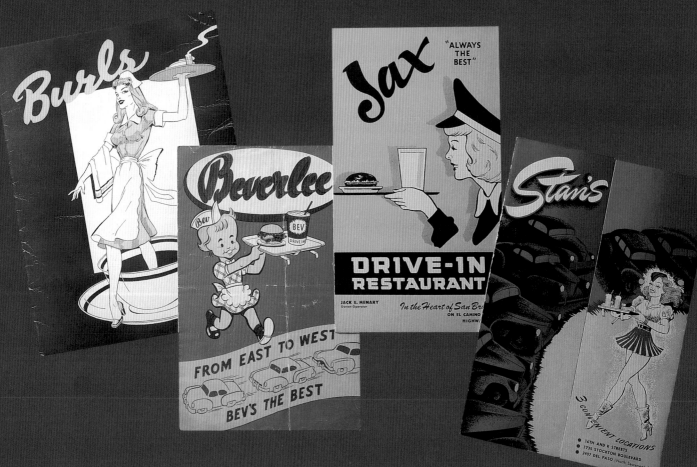

Servicing customers exclusively in their cars, drive-ins were unique in their usage of bright menu graphics. Embodying freedom of the road, their visual superiority was a combination of good design and youthful sensibilities.

Box
Special
Hamburger
and
Malt.....60¢

OSCAR'S

drive-in coffee shops

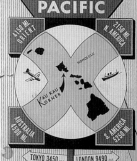

KAU KAU
KORNER
CROSSROADS
OF THE
PACIFIC

TOKYO 3450
SHANGHAI 4330
MANILA 4870
SIDNEY 4420
TAHITI 2381

LONDON 9490 MI.
NEW YORK 6720 MI.
SAN FRANCISCO 2090 MI.
BERLIN 10530 MI.

KAPIOLANI BLVD.

Menu

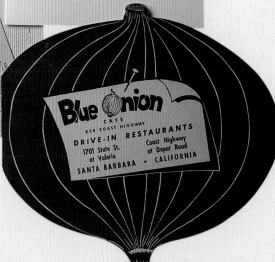

Blue Onion
CAFE
834 COAST HIGHWAY
DRIVE-IN RESTAURANTS
1701 State St. Coast Highway
at Valeria at Depot Road
SANTA BARBARA • CALIFORNIA

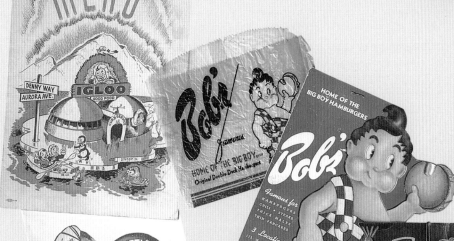

MENU

DENNY WAY
AURORA AVE.

IGLOO
GOOD FOOD

Bob's
HOME OF THE BIG BOY
Original Double-Deck Hamburger

HOME OF THE
BIG BOY HAMBURGERS

Bob's
Famous for
CHILI • STEAKS
THICK MALTS
THIN PANCAKES

3 Locations
115 W. BROADWAY
906 E. COLORADO
GLENDALE
624 E. SAN FERNANDO RD.
BURBANK

Johnnies
LITTLE
GIANT

John
PRIME

WELCOME TO
Bob's

45¢ 30¢

Bob's Big Boy
Hamburger
Made As Only
We Know How

PLEASE BLINK LIGHTS FOR SERVICE

CAR ATTEND
3

THE
Twin T-P's

AURORA AVENUE AT GREEN LAKE SEATTLE'S MOST UNIQUE RESTAURANT

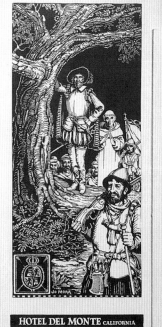
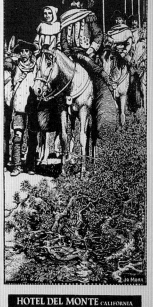

HOTEL DEL MONTE CALIFORNIA

HOTEL DEL MONTE CALIFORNIA

HOTEL DEL MONTE CALIFORNIA

HOTEL DEL MONTE CALIFORNIA

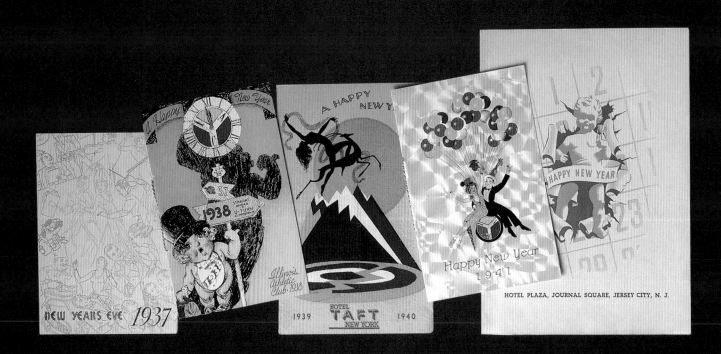

NEW YEARS EVE 1937

1939 HOTEL TAFT NEW YORK 1940

Happy New Year 1941

HOTEL PLAZA, JOURNAL SQUARE, JERSEY CITY, N. J.

Above. A unique set of menus by artist Jo Mora for the Hotel Del Monte in Monterey, California, c. 1937. *Below.* For special holidays such as New Year's, hotels produced distinctive menus for their guests. *Opposite.* Weary travelers could find respite and refreshment at journey's end in the many hotels that crisscrossed the country. Hotel restaurant and room service menus display an endless array of design solutions.

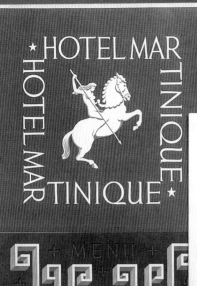

HOTEL MARTINIQUE
HOTEL MARTINIQUE
MENU

Menu

HOTEL LEXINGTON
NEW YORK CITY

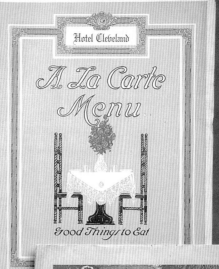

Hotel Cleveland

A La Carte Menu

Good Things to Eat

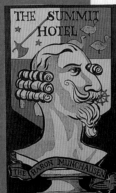

THE SUMMIT HOTEL

THE BARON MUNCHAUSEN

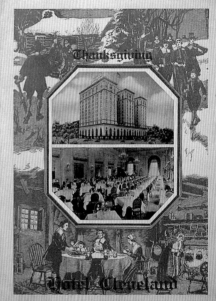

Thanksgiving

Hotel Cleveland

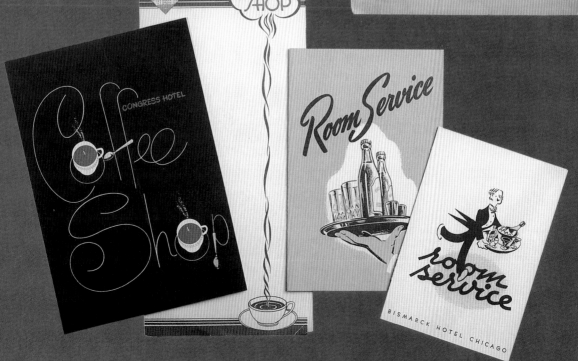

HOTEL UTAH COFFEE SHOP

CONGRESS HOTEL
Coffee Shop

Room Service

room service

BISMARCK HOTEL CHICAGO

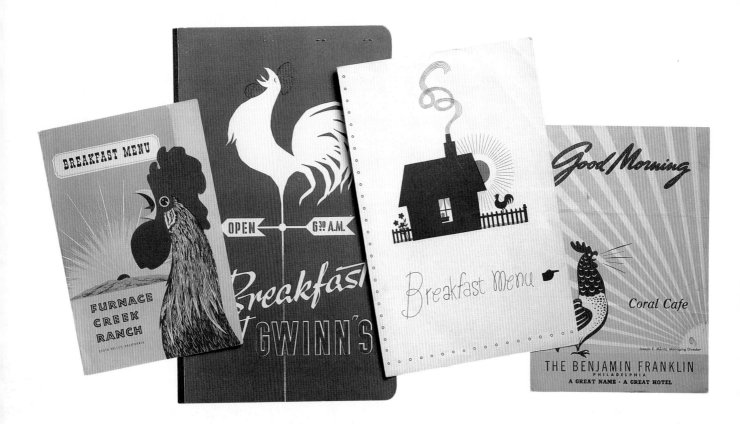

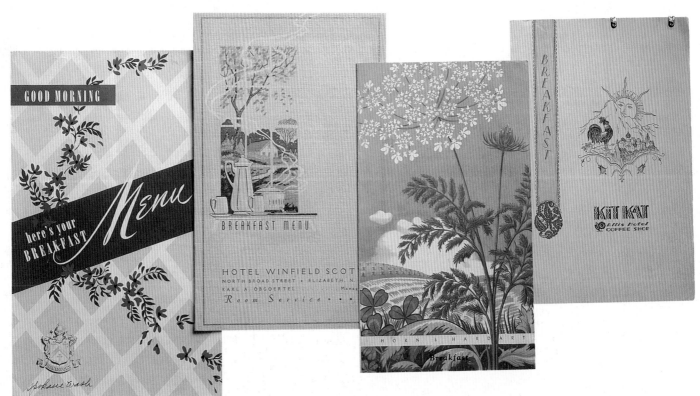

To start the day, travelers and working stiffs alike were encouraged to eat a hearty breakfast, as witnessed by these menus. *Opposite.* Photo: Disney Studios Commissary, c. 1942.

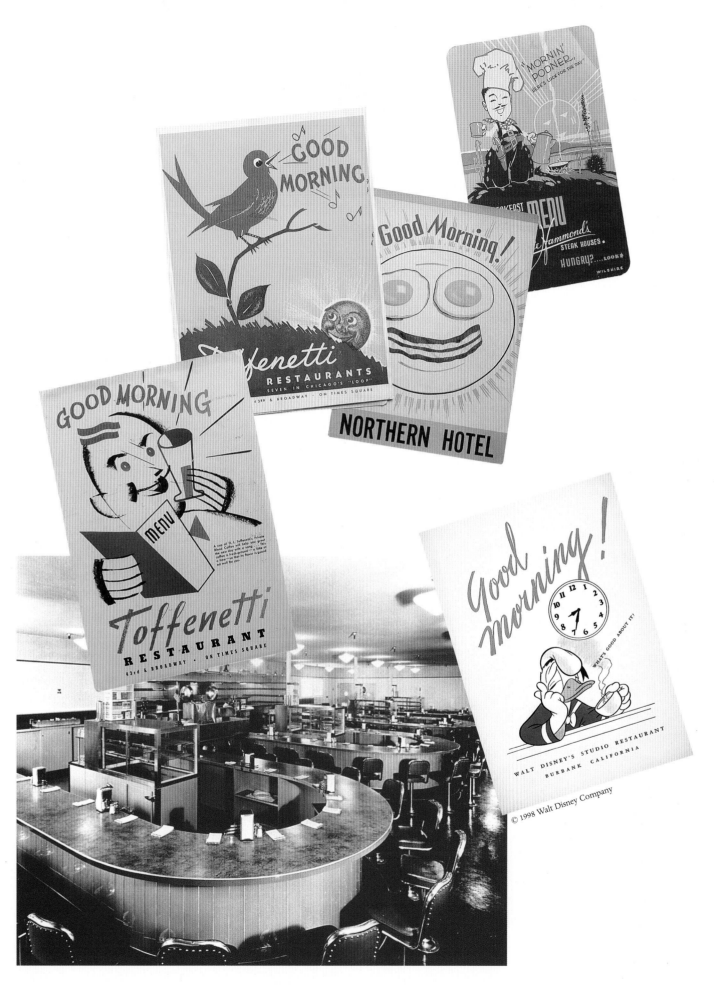

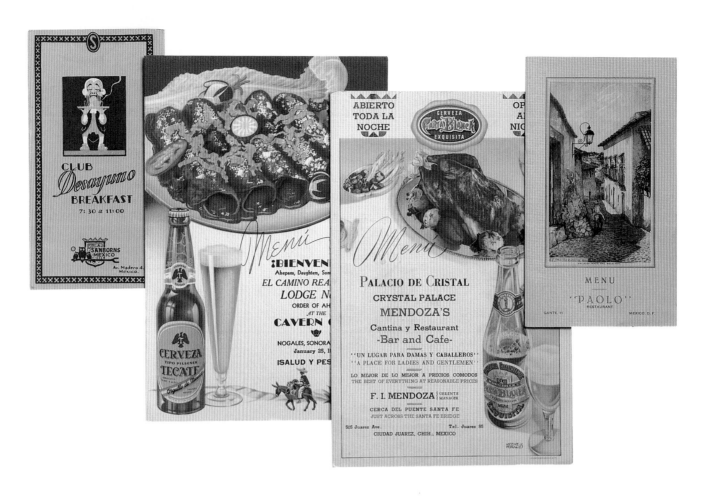

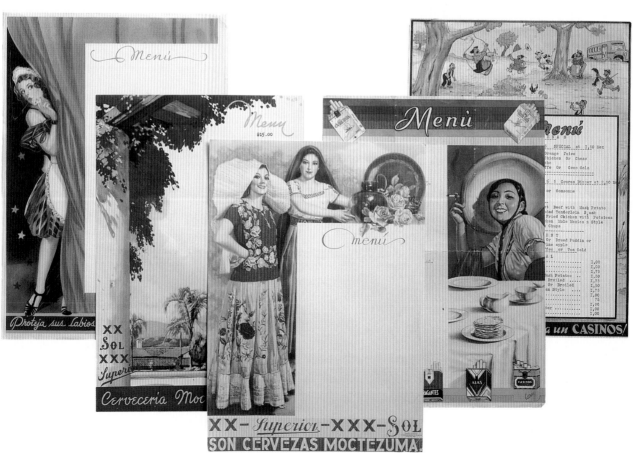

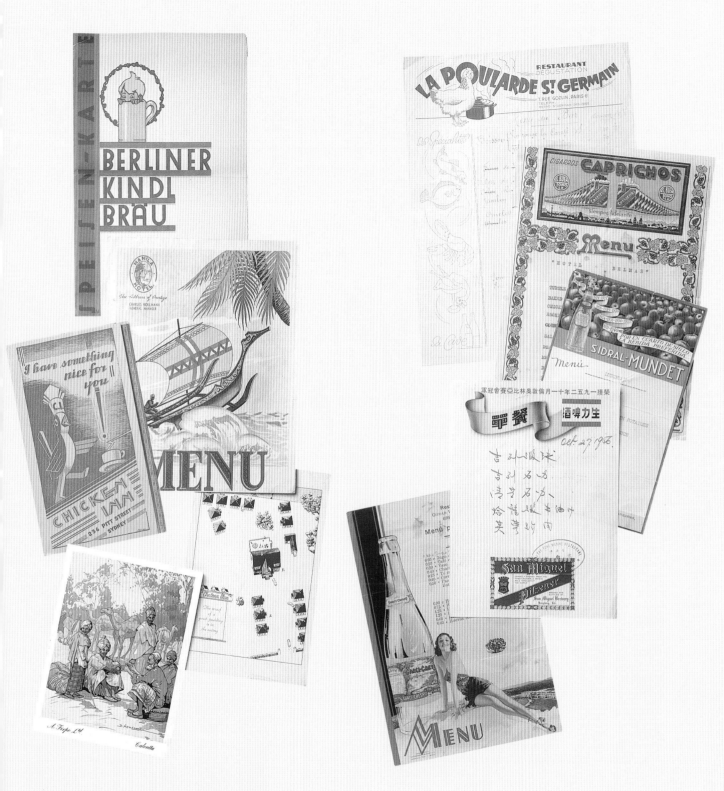

Vagabonds outside the United States found a surprising number of inventive menus with graphics to equal domestic menu art. *Opposite.* A display of Mexican stock menus, c. 1935–50. *Left.* Berliner Kindl Brau, c. 1950. Manila Hotel, c. 1955. Chicken Inn, Sydney, Australia, c. 1937. Chateau Bleu, Troi Rivieres, Quebec, c. 1940. Firpo Ltd., Calcutta. *Right.* La Poularde St. Germain, Paris, c. 1936. Hotel Belmar, Mexico City, c. 1935. Sidral Mundet, Mexico, c. 1940. Pak Fong Marine Restaurant, Hong Kong, c. 1956. Restaurant Ritz, Mexico, c. 1936.

For over a decade, Prohibition curbed the need for a separate listing of alcoholic beverages. In the years prior to America going dry, wine and beer listings were usually incorporated into the main body of a menu. The repeal of the Eighteenth Amendment in 1933 unleashed a flood of menus; the resulting designs were some of the most gratifying examples of menu art. Restaurant owners were quick to capitalize on the cocktail, a valuable source of revenue. They created special lounges and rooms expressly for relaxing and sipping alcoholic beverages. Separate wine lists were available at most first-class restaurants, and their presentation often eclipsed the food menu in size and depth. The beverage list for the Persian Room of the Hotel Sir Francis Drake in San Francisco was book-sized with several hundred brand-name liquors, domestic and imported wines and beers, champagnes, liqueurs, soft drinks, mineral waters, and mixed drinks, including the exclusive Persian cocktail.

South Seas restaurants, such as Don the Beachcomber's and Trader Vic's,

Bars and cocktail lounges abounded with superb menus extolling the virtues of imbibing. *Opposite.* Manufacturers of hard liquor offered their product on numerous menu designs as a subtle hint to enjoy a cocktail with a meal. *Above.* Hotel Statler, Boston, 1936. *Below.* Leon and Eddie's, Reno, 1943.

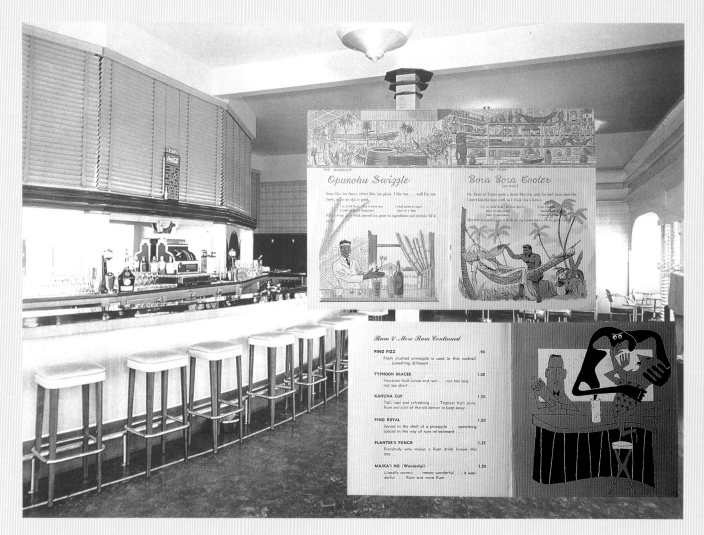

further exploited the concept of drinking as a pastime with their wild and imaginative rum concoctions. The Zombie, usually limited to a maximum of two per customer, was joined by the Mai Tai, Shark's Tooth, Suffering Bastard, and Missionary's Revenge in an endless quest to satisfy customers. Because of the good times associated with social drinking, cocktail and bar menus were often innovative. Three-dimensional replicas of restaurants or bars, die-cut table tents, pop-ups, or menus printed on cocktail napkins were typical. In a clever gimmick, the drink menu at Sugies Tropics in Beverly Hills featured exotic drinks endorsed by popular Hollywood stars of the thirties and forties who were regular customers. The drink list included Bette Davis's "Samoa of Samoa," which was described as "Liquid Lightning . . . sets you on fire!"

Bar menus often printed stories concerning the origins of a certain drink or beverage or the restaurant's history, or they included a ribald joke or two. The cocktail menu fast became a separate item to be presented to patrons only in bars and lounges or in conjunction with a meal. Beverage manufacturers enthusiastically supported the creation of new menus by providing them to restaurants at a nominal cost or free of charge. In exchange for a blank inside menu, breweries and distillers splashed their product on the front and back covers. The popularity of drinking rivaled dining out itself, and menus for wine, beer, and cocktails made up the largest category of specialized menus. Given the opportunity to sell drinks and accommodate their clientele, restaurateurs were willing and tireless promoters of Bacchus and John Barleycorn.

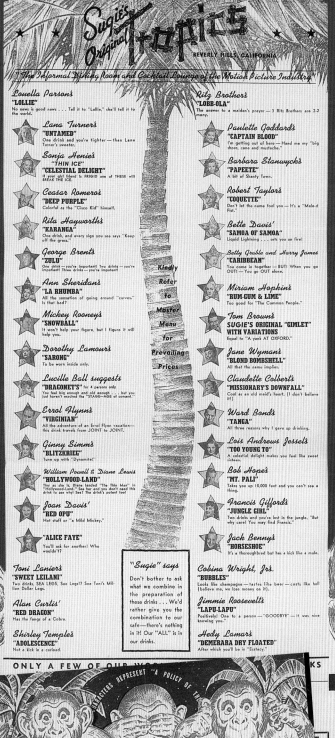

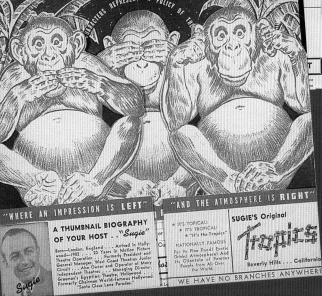

Opposite top. A gem of a brochure with cocktail recipes from Trader Vic's in Oakland, California, c. 1940. *Opposite below.* Goofy graphics highlight this cocktail menu from the Hawaiian Village, Honolulu, c. 1958. *Right.* Sugie's Tropics in Beverly Hills served drinks named after their celebrity customers listed on this charming fold-out menu from the 1940s.

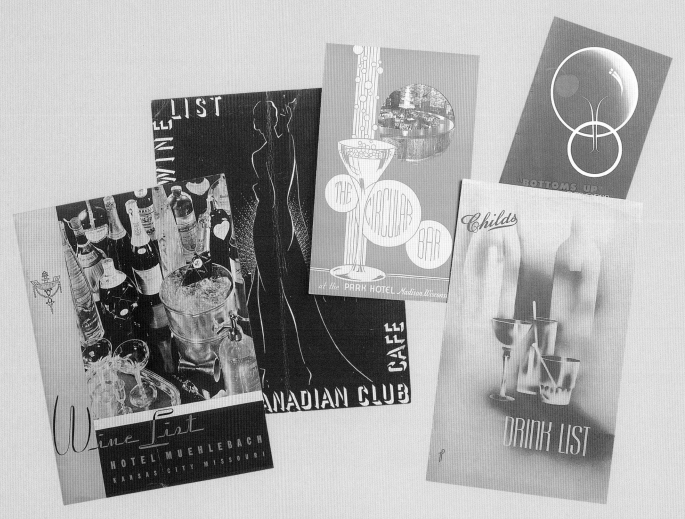

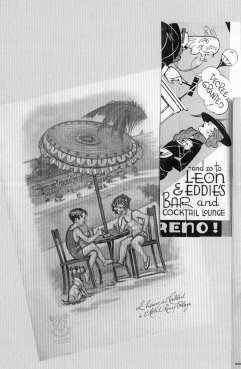

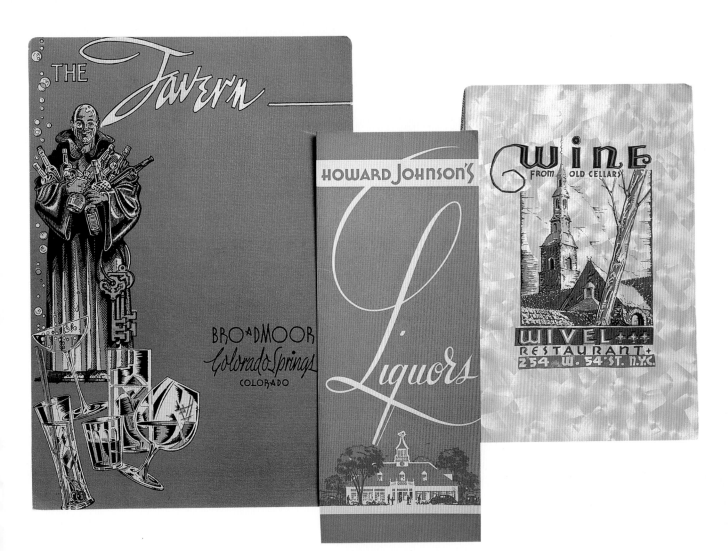

Wherever crowds congregated to have a drink, a cocktail or wine menu was sure to be nearby to guide bar patrons in their choice of spirits. *Opposite and this page.* Some outstanding examples of this distinctive menu category that could be found across the country.

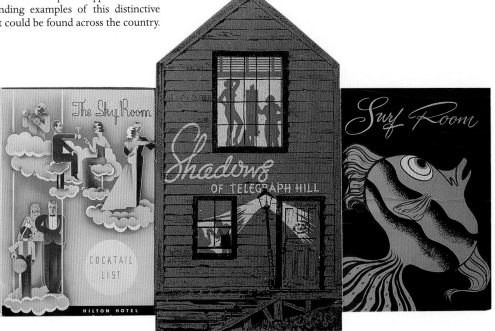

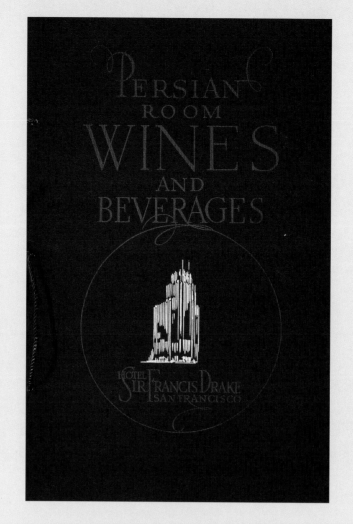

Right. The Persian Room at the Sir Francis Drake Hotel in San Francisco epitomized the extravagant cocktail menu. Over seventeen inches in height, it listed more than 350 selections, c. 1935.

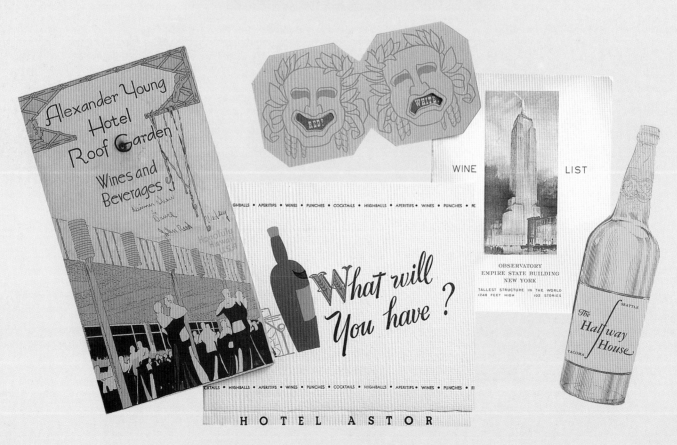

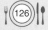

Above. During Prohibition, gambling ships off the Pacific coast provided drinkers with illegal booze and a chance to live the high-life a mere three miles off shore. Wine list, menu, and ephemera from the S.S. *Panama* and the *Tango* gambling ships. *Left.* On par with deluxe hotels of the '30s, the Ambassador Hotel and adjacent Coconut Grove offered a mind-boggling array of wine, beer, and mixed drinks, c. 1938.

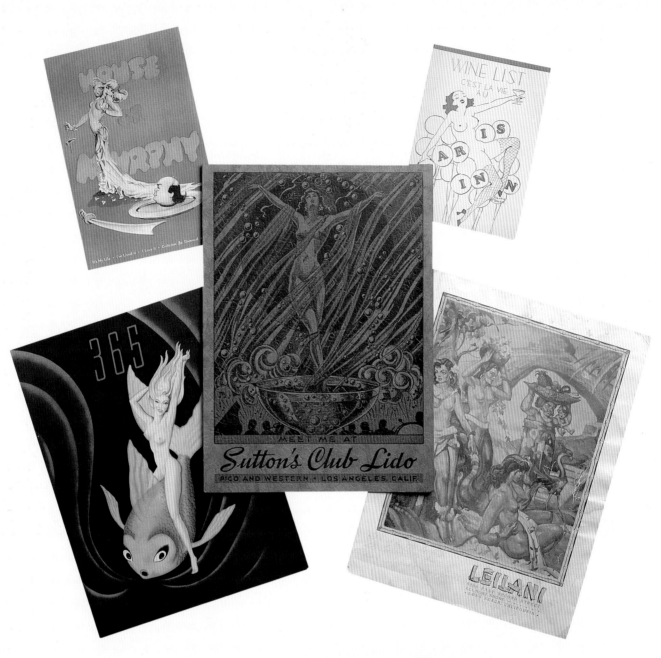

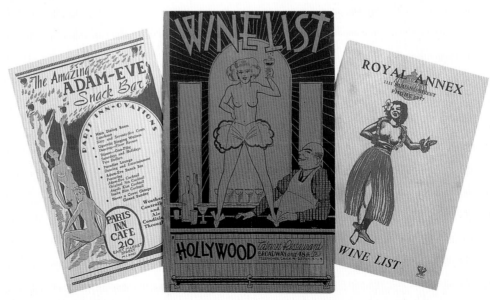

Many cocktail lounges fostered a bawdy and risqué image by placing provocative females on menu covers.

Opposite. McDonnell's restaurant in Los Angeles produced a novel drink menu that fanned out to display the restaurant's many choices, c. 1934.

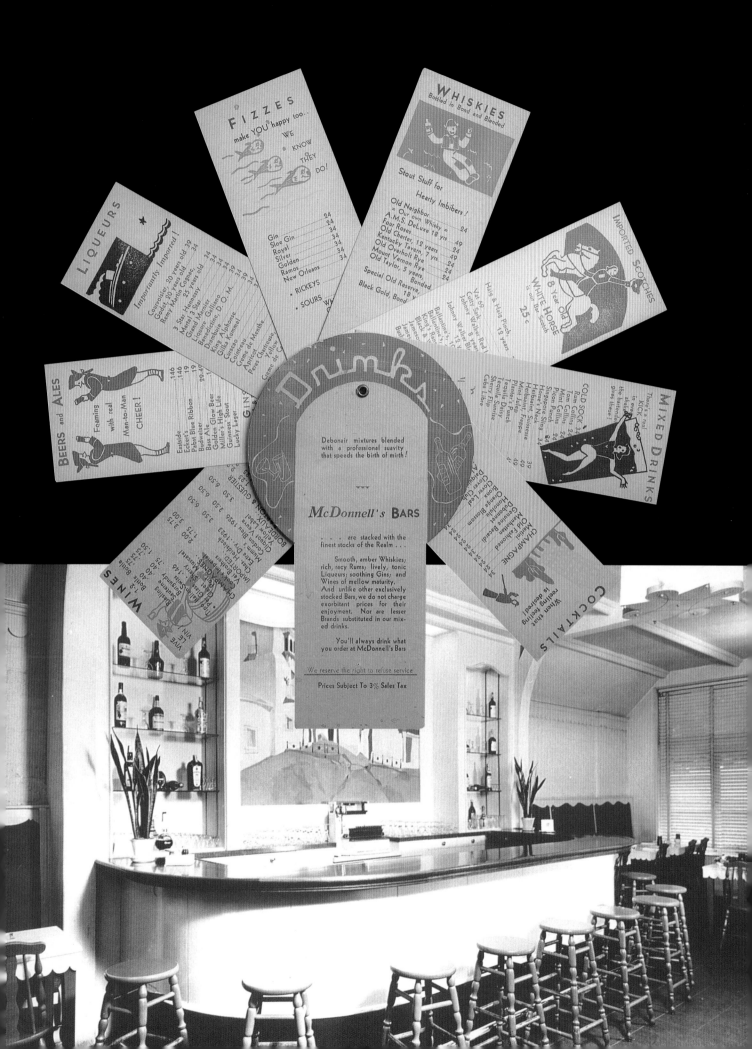

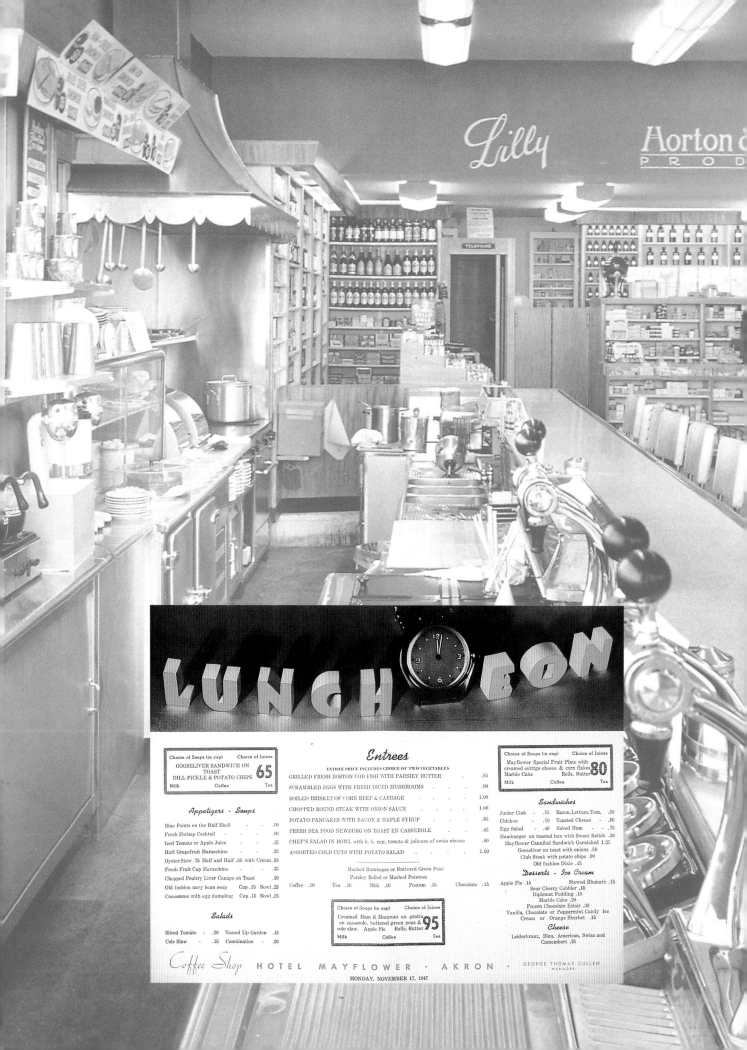

BIBLIOGRAPHY

Alejandro, Reynaldo. *Classic Menu Design: From the Collection of The New York Public Library*. Glen Cove, New York: PBC International, Inc., 1988.

Brinnin, John Malcolm, and Kenneth Gaulin. *Grand Luxe: The Translantic Style*. New York: Henry Holt and Co., 1988.

Davis, Deering. *Contemporary Decor: Restaurants, Lounges and Bars*. New York: Architectural Book Publishing Co., Inc., 1950.

Dorsey, Leslie, and Janice Devine. *Fare Thee Well*. New York: Crown Publishers, 1964.

Langdon, Philip. *Orange Roofs, Golden Arches: The Architecture of American Chain Restaurants*. New York: Alfred A. Knopf, 1986.

Mariani, John. *America Eats Out*. New York: William and Morrow and Company, 1991.

Meggs, Philip. *A History of Graphic Design*. New York: Van Nostrand Reinhold Company Inc., 1983.

"Menu As Sales Allies." *Pacific Coast Record*, October 1939.

O'Talk, Madeline. "Daily Menu Boosts Sales." *Pacific Coast Record*, March 1936.

Radice, Judi. *Menu Design 5*. New York: PBC International, 1990.

Seaburg, Albin G. *Menu Design, Merchandising and Marketing*. New York: Van Nostrand Reinhold Company Inc., 1971.

Turim, Gayle. "Vintage Menus." *Bon Appetit*, September 1994.

Van Gilder, Eugene. "The Menu Profit Maker." *Restaurant Management*, November 1936.

Weaver, Carroll. "The Menu from the Sales Angle." *Hotel Management*, March 1940.

Yenne, Bill. *All Aboard! The Golden Age of American Rail Travel*. Greenwich, Connecticut: Brompton Books Corp., 1989.

For a quick bite or a leisurely fountain treat, luncheonettes were a perfect afternoon hangout. *Opposite*. Luncheon menu from the Hotel Mayflower, Akron, Ohio, 1947. *Above*. State Coffee Shoppe, Detroit, c. 1948. Thrifty Drug Store, Los Angeles, 1941.

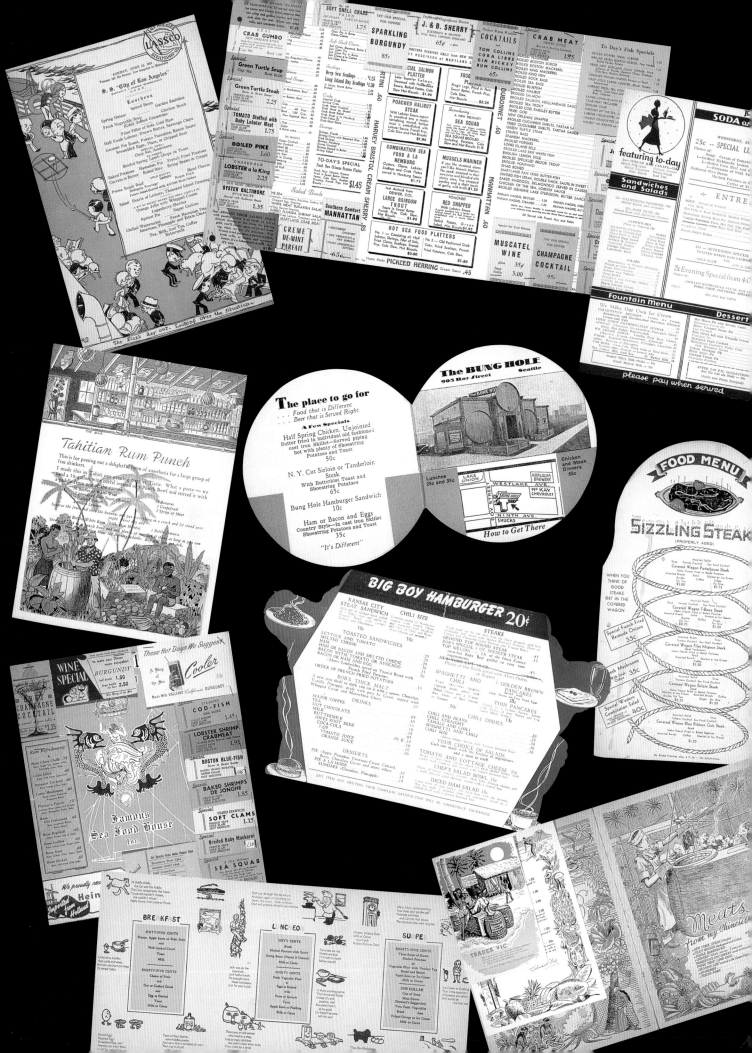